IMAGES
of America

RANDOLPH
COUNTY

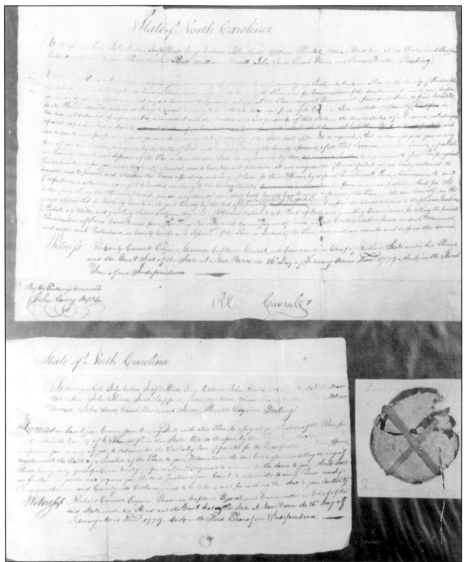

A petition from the residents of Guilford County was presented to the General Assembly in 1778, asking that the county be divided for the convenience of residents who lived far from the courthouse. Sitting at Halifax on February 26, 1779, the legislature officially recognized the lower third of Guilford as a separate county, naming it Randolph in honor of Peyton Randolph, a Virginian who had recently served as president of the Continental Congress. This handwritten copy of the legislation, complete with its official wax seal, was once part of the local county records. (Courtesy Randolph County Public Library Historical Photograph Collection.)

ON THE COVER: What appears to be an Independence Day celebration is taking place about 1915, probably in southwestern Randolph County. The photograph was found in Asheboro and is signed on the back, "I. H. [or F. H.] Skeen." The Skeen family have their historic roots in western Randolph. The lack of solid attribution is a common problem with archival photographs: the subjects start out being so well known that the owners do not see a need to note the date, place, or names. As time and owners pass, the best-known faces gradually lose their identity. (McKay Whatley.)

IMAGES
of America

RANDOLPH
COUNTY

L. McKay Whatley

ARCADIA
PUBLISHING

Copyright © 2010 by L. McKay Whatley
ISBN 978-0-7385-8673-1

Published by Arcadia Publishing
Charleston, South Carolina

Printed in the United States of America

Library of Congress Control Number: 2010928317

For all general information, please contact Arcadia Publishing:
Telephone 843-853-2070
Fax 843-853-0044
E-mail sales@arcadiapublishing.com
For customer service and orders:
Toll-Free 1-888-313-2665

Visit us on the Internet at www.arcadiapublishing.com

CONTENTS

ACKNOWLEDGMENTS

Just as Tip O'Neil famously observed, "all politics is local," so is all history fundamentally local. Asheboro lawyer J. A. Blair, with time on his hands in 1890, gathered and wrote the first county history. "Miss Laura" Worth, widow of Dr. Worth's grandson Hal Worth, for 50 years was the recognized guardian of county history. When the new library opened in 1964, the "Randolph Room" opened as a genealogical resource by Barbara N. Grigg and Carolyn Hager and became the center of local history. I conducted my historic preservation survey in 1978 with the invaluable help of local historians like Calvin Hinshaw of Julian, Frances Elkins of Archdale, and Francine Swaim of Liberty. Today I am grateful for the support of this and other projects by Warren Dixon, Wally Jarrell, Cindy Wilkins, Fran Andrews, Marsha Haithcock, Adrian Whicker, Dan Routh, and Richard Wells. I want to thank my long-suffering advisors and editors at Arcadia, Lindsay Harris and Maggie Bullwinkel. I am grateful for and appreciate the quizzical understanding and support for my odd projects by my sons Roman and Vladimir.

This book could not exist without the unintentional contributions of amateur and professional photographers who, since the 1850s, have recorded the history of Randolph County. One example is Hugh Parks Jr. (1875–1931), son of the Franklinville mill owner and an amateur photographer who documented much of eastern Randolph at the turn of the 20th century. At a time when photography itself was less than 50 years old, Parks documented every aspect of life, white and black, agricultural and industrial, and work and play. Some of his images, particularly those of African Americans at home, included here, are uniquely valuable. Without the dedication of volunteers such as Hugh Parks, our visual understanding of Randolph County would be immeasurably impoverished.

Unless otherwise noted in the caption, the photographs herein come from the Historical Photograph Collection maintained by the Randolph County Public Library. I am pleased that almost all of the photographs printed here, including those from my personal collection (marked MW), are available online by searching the historic photograph section of the library's Web site: www.randolphlibrary.org. That online resource now contains hundreds of more images than I could fit here. Additional information on many scenes and an index is available on my blog: randolphhistory.wordpress.com. For future public exhibits on Randolph County history at the 1838 Franklinsville Manufacturing Company mill on Deep River, see www.cottonmillmuseum.com.

INTRODUCTION

Randolph County is the 10th largest county in geographic land area in North Carolina (787.34 square miles). The county is divided by two river basins: the Deep/Cape Fear, which flows into the Atlantic past Wilmington, and the Uwharrie/Peedee, which exits through Georgetown, South Carolina. In 2009, there were about 142,000 residents in the county, which made it the state's sixth-highest populated county, with slightly higher population density than the state average (165.8 persons per square mile). Of those residents, 82 percent were Caucasian, 11 percent Hispanic, and less than six percent African American—a low percentage that has not changed much since antebellum times.

Almost every one of the world's religions is, or has been, represented in the county. The same can be said of almost every party, faction, or philosophy of American political thought. Sometimes those ways of making sense of life, living, and the universe have clashed, butted heads, or even shot at each other trying to prove who is "right." From the War of the Regulation, to the Tory Guerrilla War of the Revolution, to abolitionism and the Underground Railroad, to the Inner Civil War, to modern party politics, the residents of Randolph County have usually taken the contrarian position on social and political issues. This heritage of dissent, of swimming against the stream, is something that has not been properly understood or analyzed by Southern historians, but which has contributed much to the advancement of social justice, education, industrialization, and modernization of North Carolina.

Every visitor to Randolph County is first stuck by the beauty of its landscape. "It is said of Randolph that it is one county where every road is a scenic highway. Every mile has its view. This combination of woods, of numerous streams, rolling hills swelling into mountain knobs and ridges, all interspersed by occasional wide open lands or "savannahs," as Lawson called the prairies, makes Randolph an exceedingly attractive section," said *Our State* magazine editor Bill Sharpe in 1958.

Despite their beauty, Randolph County residents have always used their landscape assets. Once forests were seen as merely the source of wood products, rivers harnessed for their potential power, and land farmed, pastured, mined, or reshaped for the products it could produce for sale. Today as Randolph and the surrounding Piedmont undergo sweeping changes in land use patterns, employment statistics, demographics, and energy use, the landscape is still in use, in different ways. It has been assuming a cultural value, with a new appreciation for its inherent beauty, its history, and its recreational uses. The county's heritage assets have become appreciated for their potential for tourism and for providing a tangible link to the history of the county. History and geography and landscape and heritage preservation, all contribute toward Randolph County's unique sense of place.

The prehistoric main street of North Carolina was the ancient Indian Trading Path, which ran diagonally across the state from Virginia into Georgia. Its route across northern Randolph County brought countless explorers into the area such as John Lawson, who in 1701 visited a fortified Native American village located near Ridge's Mountain. This excavation on Caraway Creek, sponsored by the Archaeological Society of North Carolina in June 1936, was the first to spark statewide interest in North Carolina's prehistory. The junior member of the team was Joffre Coe, a student who became director of the UNC Research Laboratories of Archaeology and dominated archaeology in the state until his retirement in 1982. Twelve burial pits were unearthed, with artifacts such as trade pipes, animal tooth pendants and necklaces, shell beads, and ear plugs. No further excavations have ever been conducted. (Courtesy of the Research Laboratories of Archaeology, the University of North Carolina at Chapel Hill.)

One

A PLACE TO CALL HOME

In 2008, it was estimated that some 60,000 homes stand in Randolph County, with about 77 percent of them owned, not rented. But the place now called Randolph was home to homo sapiens long before colonists traveled the Indian Trading Path and the Great Wagon Road from Virginia and Pennsylvania. The county was home to thousands of years of aboriginal life, and the stone artifacts of those people still turn up in the wake of bulldozers to remind people of their prior claim on the land. And there were more peoples than John Lawson's oft-cited Keyauwees (though that name survives in anglicized form in our familiar "Caraway" mountains, creek, and racetrack): the "Totero," or Tutelo, lived on the Uwharrie, and other relatives of the Catawba or Siouan tribes, with names now lost, roamed the county.

Once pioneer settlers began arriving in the 1740s, the trickle became a flood and has not stopped yet. A Colonial home might start out as a cellar or hillside dugout, evolve into a log cabin, expand into a frame house with timbers pegged together, and be replaced after 100 years by some elaborate Victorian concoction out of a catalog. What is seen of the history of Randolph County today is a small fraction of what was once here, and what survives is usually cloaked today in modern dress. Always, though, the appearance reflected the values and tastes of the individual and should tell a lot about the places they called home.

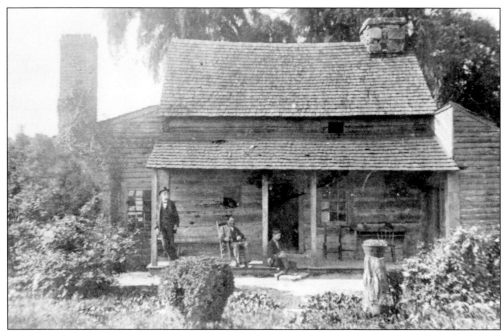

This is the log cabin home of Enos Blair (1750–1834), built around 1770. The V-notched log structure is now hidden behind later additions, but it is one of the oldest houses illustrated in T. T. Waterman's classic book *The Early Architecture of North Carolina*. One room and a loft, with a massive stone fireplace built inside the pen of logs, the Blair house still stands near Archdale-Trinity Middle School and may be the oldest remaining home in Randolph County.

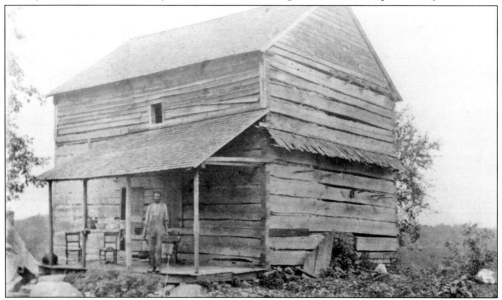

The William Cox "Old House" is a full-dovetail-notch oak log cabin built in 1761. It stood 2.5 miles south of Ramseur on what became "Oakland Farm," the demonstration farm of Hugh Parks of Franklinville. Parks was the first farm owner in the region to keep purebred stock such as Aberdeen-Angus cattle, Berkshire hogs, and White Leghorn poultry. At the time of this picture, around 1900, it was used as a tenant house. (MW.)

Jobe Allen (1816–1900) was a grandson of Pennsylvania emigrant John Allen, whose sister married Herman Husbands. His father was Nathan Allen and his mother Martha Cox. The overshot coverlet used as a backdrop serves as a reminder that the Quakers of the Holly Spring area were well known for their hand-weaving skills.

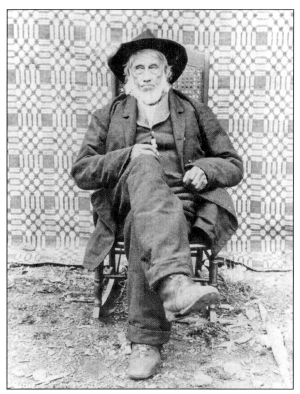

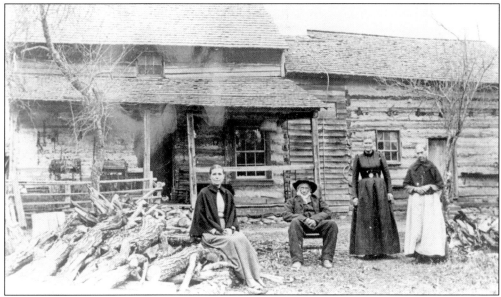

Jobe Allen built this home after moving to the Holly Spring community in 1830. His daughter Dinah Susannah (1851–1934) and wife Welmet Kemp (1819–1888) stand to the right; the woman seated on the woodpile is unidentified. The original Allen log cabin is the section to the left; it is almost identical to the Blair house. A second cabin was built to the right and connected by a covered passage (now covered with clapboards) that is today called the "Dog Trot" or "Possum Trot" type of cabin plan.

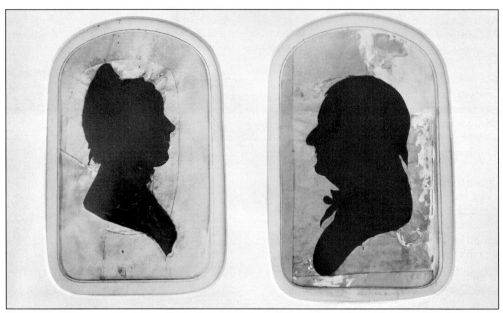

These are silhouette portraits of Jeduthan Harper (1736–1819) and his wife, Gizeal Parke Harper (1755–1845). Harper was a lieutenant colonel of the Chatham County militia, where in 1776 he served as sheriff. He moved to Randolph County in 1781, where he served as register of deeds and then in 1787 was elected to be the county's second clerk of court. Harper's son Jesse (1787–1851) also served as clerk of court, daughter Ann Elizabeth married future governor John Motley Morehead of Greensboro, and daughter Sara married Alexander Gray, a merchant who became the county's wealthiest man and largest slave owner. Jeduthan Harper's will emancipated his own slaves and provided them with land, horses, and cash. (Courtesy of Blandwood Mansion.)

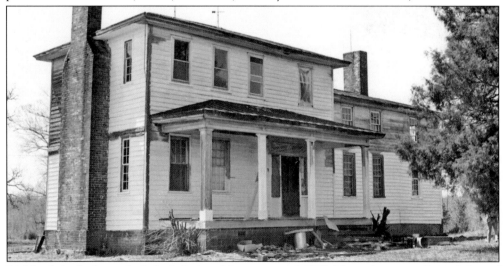

Richlands is the home built by Jeduthan Harper around 1795. Harper's estate adjoined that of Alexander Gray, and the hip roof was probably remodeled in the 1850s to match the nearby Gray plantation house. The northwest corner of Randolph was known from early Colonial times as "the Rich Lands of the Uwharrie," due to the fertility of the alluvial bottomlands. The house has unusually fine Federal-period interior woodwork and is listed on the National Register of Historic Places. The Harpers and the Grays are buried in the nearby Gray family cemetery.

Jonathan Worth (1802–1869) practiced law in Asheboro for almost 40 years. He was elected to the North Carolina House from Randolph County in 1832 and to the North Carolina Senate in 1840. Born into the Guilford County Nantucket Quaker community, he married Martitia Daniel in 1824, the same year he began a law practice in Asheboro. Worth served as state treasurer during the Civil War and won election against W. W. Holden in 1865 to become the 39th governor of North Carolina. He was reelected in 1866, but refused to run again in 1868. He is the only state treasurer to have subsequently been elected governor and is buried in Oakwood Cemetery in Raleigh. Worth's granddaughter Adelaide married Josephus Daniels (1863–1947), founder of the Raleigh *News and Observer* publishing family. (Dustcover illustration courtesy of Jonathan Daniels from *Jonathan Worth: A Biography of a Southern Unionist* [1965]; used with the permission of UNC Press.)

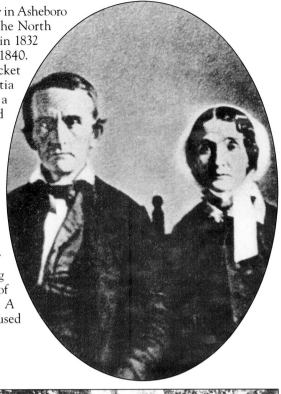

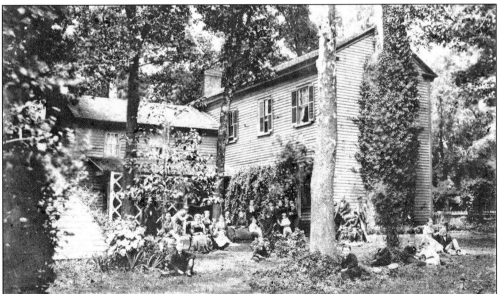

The only known photograph of the Jonathan Worth home shows its back garden. The house fronted on what is now Worth Street, where a massive oak tree still marks its front yard. It burned in 1888. This view from Main Street looking west was made on the occasion of the 25th wedding anniversary of David and Julia Worth of Wilmington, June 1878. Mrs. J. W. Worth is seated in the center, wearing a white cap and scarf. Elvira Worth is seated in a group with her Walker step-children at the tree on the right. The pyramidal structure to the left is an ice house.

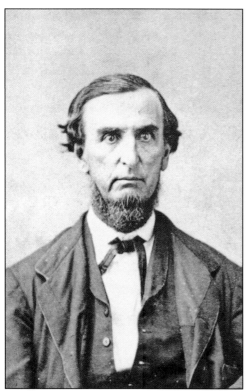

This is Dr. John Milton Worth (1811–1900) around 1850. "Milton" Worth studied medicine at the Medical College in Lexington, Kentucky, and married Sarah, the daughter of Peter Dicks of New Salem. He served in the state senate from Montgomery County and then moved to Asheboro where he ran a store to supplement his medical practice. During the war, Worth was in charge of the Salt Works outside Wilmington, where many Quakers and conscientious objectors were given alternative service. He was elected state senator in 1870, then state treasurer in 1876, serving until 1885. John Milton Worth was one of the most active investors in Randolph County's postwar industrial development. He served as president of the county's first bank, the Bank of Randolph, and as president, treasurer, director, or stockholder of the mills at Cedar Falls, Franklinville, Central Falls, and Worthville. Worth's daughter Delphia Louise was the mother of Robert Worth Bingham (1871–1937), founder of the Louisville, Kentucky, *Courier-Journal* publishing family.

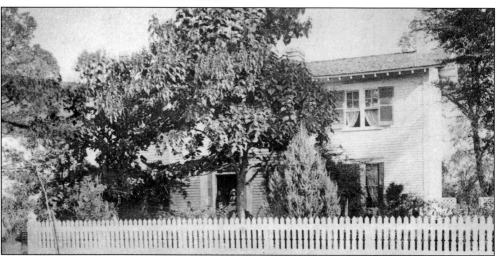

Dr. J. M. Worth built this house at the northeast corner of Worth and Cox Streets just after the birth of his youngest son, Thomas Clarkson Worth, in November 1854. Built in the Greek Revival style with an elaborate walnut staircase, wainscoting, plaster cornice, and ceiling, it was the showplace of antebellum Asheboro. During the war, it was the military headquarters of Col. A. C. McAlister (1838–1916), commander of the state troops sent from Raleigh to put the county under martial law. He is said to have installed a secret staircase exit from the upper-west bedroom. McAlister married Dr. Worth's daughter Adelaide, and the McAlisters added an elaborate Eastlake-style porch to the house in the 1880s. The house was demolished in 1958; the public library today stands on its site.

Henry Branson Elliott (1805–1863) was one of the most progressive figures of antebellum Randolph. Son of the local clerk of court Benjamin Elliott, Henry graduated from University of North Carolina, Chapel Hill in 1826 and then went on to Princeton. In 1836, he encouraged his father and their partners Phillip and Alexander Horney to add cotton-spinning equipment to their gristmill on Deep River in Cedar Falls and successfully ran that mill for the next 20 years. He was involved with the Plank Road and advocated for railroads, but after losing a considerable amount of money in unsuccessful mining ventures in the 1850s, he moved his family to the Missouri frontier to start anew. (MW.)

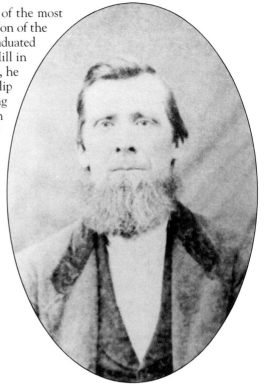

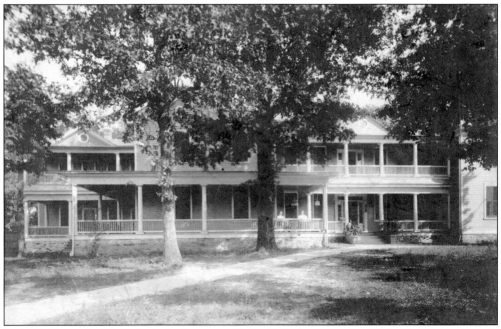

In 1837, Henry B. Elliott built his home in Cedar Falls, but around 1850 he decided to have it taken apart and reassembled in Asheboro. In 1894, clerk of court James T. Millikan expanded it to create the Central Hotel. The hotel was demolished in 1958, but stood on the site of the present RBC Centura building, Asheboro's tallest structure.

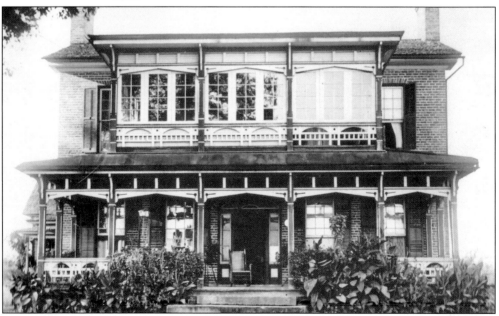

This is Elisha Coffin (1779–1871), from a tintype probably taken about 1855 when Coffin had returned to the community of his birth (New Garden in Guilford County) to run the college gristmill. He is dressed as a typical Quaker, even though he had been disowned 50 years before. In 1821, as recounted by his cousin Levi Coffin, Elisha and his father personally smuggled the escaped slave Jack Barnes to safety in Indiana. In 1838, he and 12 other Quaker idealists established the Randolph Manufacturing Company mill in Franklinville to provide jobs for widows and orphans. (MW.)

Elisha Coffin built his home on the hill overlooking the factory in Franklinville around 1835. When he left town in 1850, he sold it to George Makepeace. The south front is shown here about 1910. The original Greek Revival brick has details out of a Boston handbook and evokes Coffin's ancestral Nantucket. George Henry Makepeace added the two-story sleeping porch or "gallery" in the Eastlake style around 1880. (MW.)

Robert P. Dicks was the son of James and Nancy Coltrane Dicks. He was educated at the Hillsboro Military Academy and graduated from Trinity College. His father, James Dicks (d. 1883), was the son of Peter Dicks, the miller who first recognized the mill power potential of the location that came to be Randleman.

Randolph County's most impressive Victorian mansion was Waverly, decorated here for the Fourth of July. The house was built in 1881 by Thomas C. Worth and remodeled around 1886 in the Second Empire style by Robert P. Dicks, the secretary-treasurer of the Naomi Falls Manufacturing Company and the grandson of Peter Dicks. The house sat in the center of town, in the parking lot of the modern public library. It featured an octagonal library, a music room, and seven bedrooms and bathrooms on each floor. It was one of the first houses in the county to boast of gas lights and running water, pumped by a windmill in the yard. It later served as Pugh Funeral Home and was torn down in the mid-1960s.

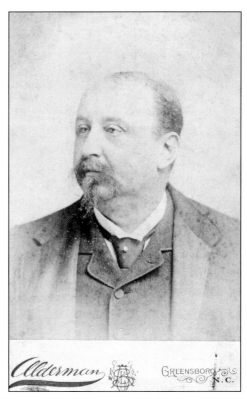

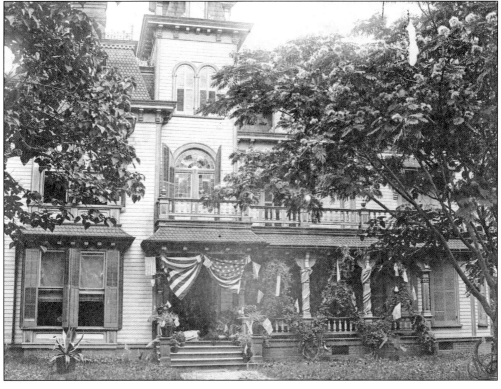

Arthur Hill stands in front of his home in Strieby. A large community of free blacks, including the Hills, Waldens, and Lassiters, lived in southwest Randolph.

Taken by Hugh Parks, this is the porch of an unidentified house in eastern Randolph with an African American family. The ramshackle house could date to the 18th century, but sadly, nothing particular is known about the two women, two babies, and the girl. (MW.)

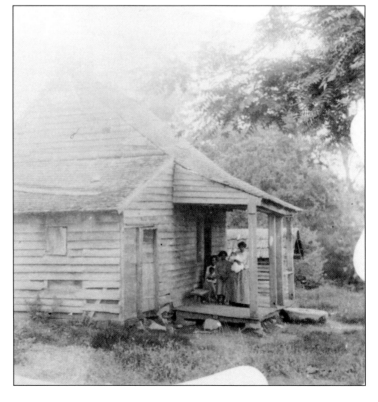

The home of the Nelson Luther family is under construction near New Hope around 1915 by John Hill, Burl Allen, Nelson Luther, and Nish Hardister. (MW.)

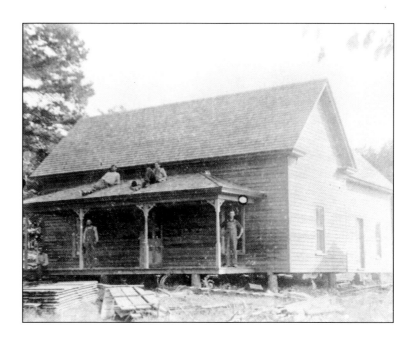

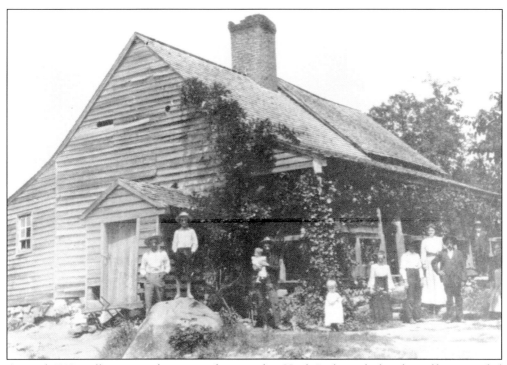

Around 1910, mill owner and amateur photographer Hugh Parks took this shot of his extended family gathered at the home of his grandparents John (1797–1887) and Sarah (1799–1882) Moffitt Parks in the Parks Crossroads vicinity. (MW.)

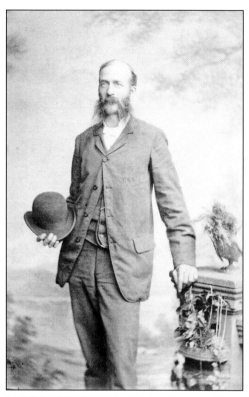

William Penn Wood had a long and successful career as a storekeeper and merchant in Asheboro, first at the old courthouse square and then in partnership with W. H. Moring on Fayetteville Street. His second career began in 1911 when he was elected state auditor, an office he held for 10 years. His Second Empire–style residence on East Salisbury Street was very similar in appearance to several other homes in Asheboro. What was most unusual was the elaborate Victorian garden landscaping of the W. P. Wood home.

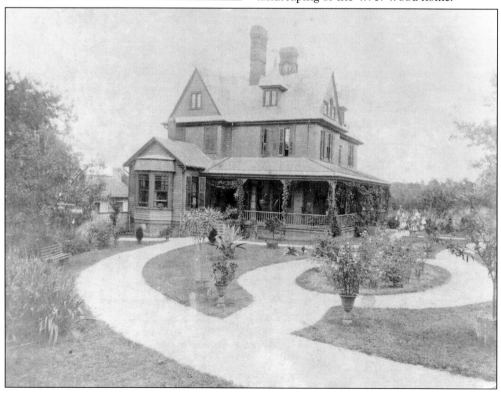

Capt. William Gould Brokaw was the grandson of railroad baron Jay Gould. Brokaw maintained houses in Manhattan; Saratoga, New York; Tuxedo Park, New Jersey; and Trinity, North Carolina. Quail hunting was Brokaw's passion, and beginning in 1896, he assembled a 30,000-acre hunting preserve in Davidson and Randolph Counties. Fairview Park boasted a private railroad siding, racetrack, polo field, golf course, 35-stall barn, kennel, and cottages for gamekeepers and trainers. The 500-acre tract immediately around his Manor House was stocked as a private deer park. Brokaw sold the property in 1938 and died in South Carolina in 1941.

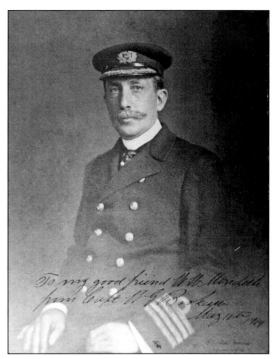

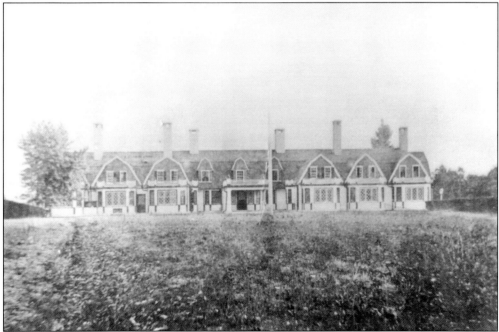

Fairview Park was built in 1896 and burned in 1922. Randolph was highly regarded as quail-shooting country in the late 19th and early 20th centuries; and the 2,300-acre Brokaw estate was the largest hunting lodge of them all. The 160-foot-long house featured a library, billiard room, gun room, gym, bowling alley, shooting gallery, Turkish bath, squash court, and indoor swimming pool. The grounds featured a racetrack, polo field, golf course, kennels, 35-stall barn, private deer park, cottages, and a log cabin in the Swiss Chalet style.

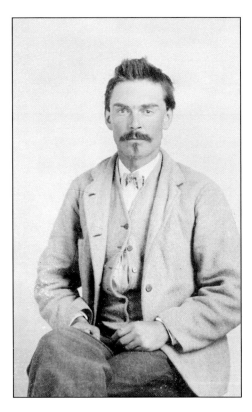

An unidentified tintype print of a well-to-do Randolph County man is from the Eva M. Stout album, around 1860. His civilian sack coat and vest are of the style that would soon be turned into standard Confederate uniform patterns. His facial hair is in the latest French style: the *mouche* (French for "fly") covered the area under his lower lip; during and after the Civil War, it came to be called "an imperial." (MW.)

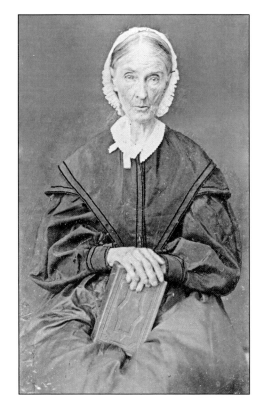

The only readable inscription on the back of this *c.* 1860 tintype from the Eva M. Stout album is "Susan." Perhaps that was the name of this otherwise unidentified but formidable Randolph County woman. Her clothing— expensive, yet drab fabric with a plain linen bonnet and collar—is severely proper for a Quaker matriarch. The unidentified portrait photographer has captured something unusually compelling about her. (MW.)

This is John M. Odell (1831–1910) around 1860. Odell, a native of Cedar Falls, was a clerk in the company store of the factory there when the Randolph Hornets (Company M of the 22nd North Carolina Infantry Regiment) were organized in 1860. Odell was elected the first captain of the company. A student of George Makepeace, after the war he became one of the most influential textile mill owners in North Carolina. (MW.)

Dr. Phillip Horney Jr. (1791–1856) is with his wife, Martha (Patsy) Smith (d. 1871), around 1850. A prominent local physician, Dr. Horney and his son Alexander were the original partners with the Elliotts in the Cedar Falls factory. Like Elisha Coffin, his neighbor in Franklinville, Horney was born a Quaker but was disowned for marrying a non-Quaker. He was one of the founders of the Franklinville Methodist Church. (MW.)

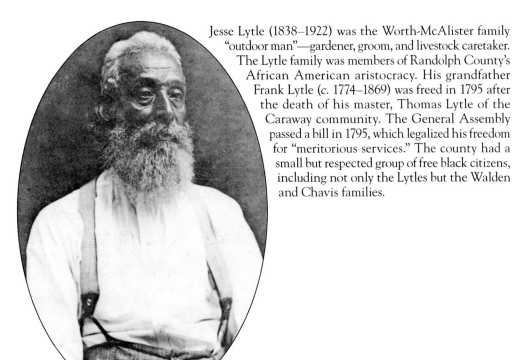

Jesse Lytle (1838–1922) was the Worth-McAlister family "outdoor man"—gardener, groom, and livestock caretaker. The Lytle family was members of Randolph County's African American aristocracy. His grandfather Frank Lytle (c. 1774–1869) was freed in 1795 after the death of his master, Thomas Lytle of the Caraway community. The General Assembly passed a bill in 1795, which legalized his freedom for "meritorious services." The county had a small but respected group of free black citizens, including not only the Lytles but the Walden and Chavis families.

Longtime president of Trinity College, Braxton Craven (1822–1882) was one of the county's most prominent and respected citizens of the 19th century. Born in the Cox's Mill area of the county, he was raised in a number of foster families. At age 18 he was licensed to preach by the Methodist Church, and he spent the rest of his life preaching and teaching. This portrait shows him around the year 1850. Craven was an author, writing and publishing fiction in the school literary magazine, *The Evergreen*. His story, "Naomi Wise, or The Victim," was the first record in print of the county's famous ballad.

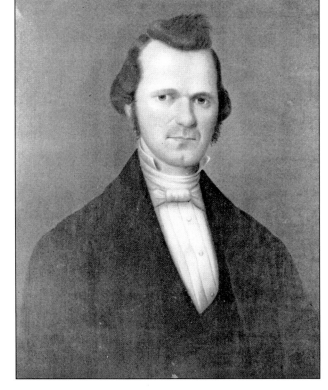

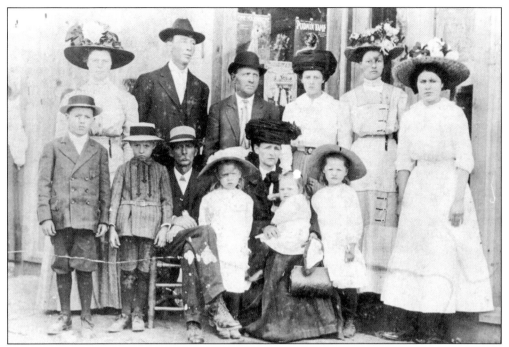

This is the Micajah H. Lassiter family (photographed about 1910). The Lassiter House stood on the road to Lassiter's Mill near Mechanic in Cedar Grove township. Micajah died soon after this photograph was taken.

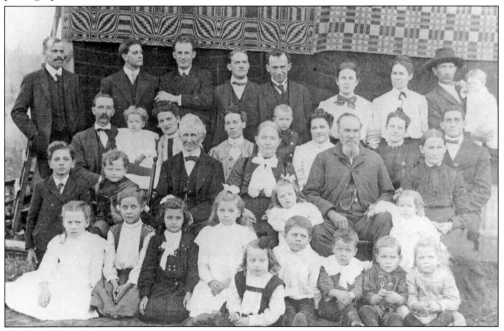

The Hinshaw family was known as professional hand weavers even back in their native Ireland, which may be why two overshot coverlets were used as the photograph backdrop. Pictured are, from left to right, (fourth row) Amos Hinshaw, Waldo Casper Cox, Herbert Cox, Stuben Cox, F. T. "Coy" Cox, Grace Cox, Louelvia Bingham, and Will Bingham. The rest are unidentified.

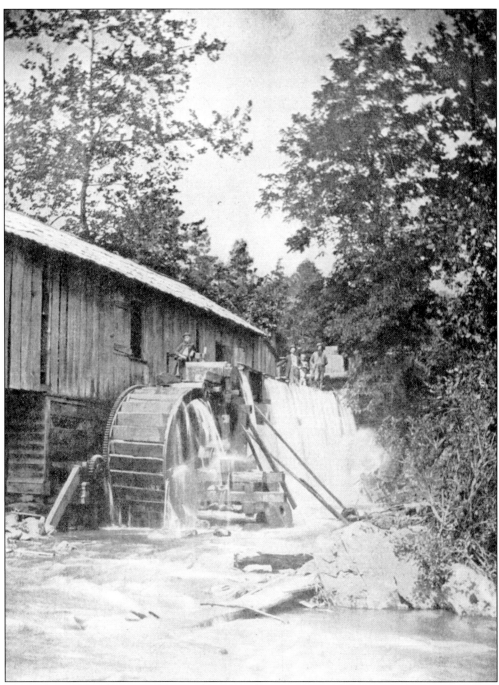

Pictured is "Old Mill near Ashborough, N.C.," from page 419 of the *Royal Photograph Gallery*, an 1893 world travel guide, which gushed that the image was "one of those picturesque and attractive scenes which frequently greet the eye of the traveler in the Old North State . . . equally suggestive of antiquity and poetry." A sash or up-and-down sawmill was the usual way to cut lumber before the invention of the circular saw in 1844, and this is the only known image of one from the county.

Two

A Place to Grow

In 2008, approximately 17,000 acres in the county were farmed as cropland, with the average farm size being 99 acres. In 1860, ninety percent of the population had some connection with farming. There were a total 1,800 farms, with 1,233 farms having fewer than 100 acres. Just four farms had more than 500 acres, and there were none with more than 1,000 acres—a striking contrast with the huge plantations of eastern North Carolina. Though farm size may be shrinking, the amount of land devoted to forestry has actually increased since the 1930s, a result of the wholesale clear-cutting of the first-growth forests that happened after the railroads arrived in the 1880s. Agriculture in Randolph County has always been considered "subsistence" farming—farming for food, rather than for cash. Gardening was generally a home activity, done to suit personal tastes. Vegetable farming on a commercial scale was called "truck" farming, and only became a significant activity for farmers adjoining the Deep River Mill Villages. Most farmers before 1940 concentrated their activities in raising wheat or corn, staple crops, which, when milled into flour and meal, could easily be stored for use in the winters. Moreover, surplus production of either could be fermented or distilled into beer, brandy, or whiskey—all of which not only had a longer shelf life but real cash value. And that created a need for gristmills grinding grain and corn, sawmills sawing lumber, and potters making jugs for liquor. So a farmer's year not only involved growing but also milling, distilling, potting, and " 'shining."

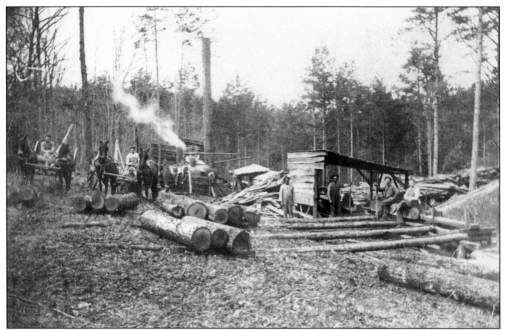

A dozen men and boys take a break to have their picture taken at Trotter's sawmill in Cedar Grove township, powered by a stationary steam boiler set up in the woods. Jonathan and John Milton Worth brought the first steam-powered circular sawmill such as this to the county in 1851, to cut the lumber needed to build the Plank Road.

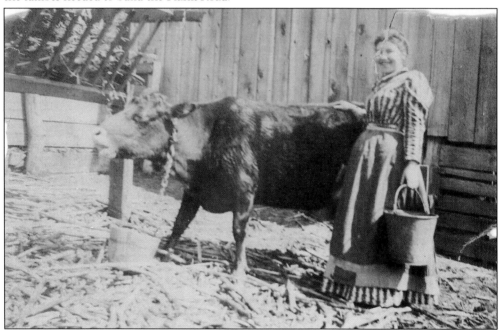

A Franklinville woman is preparing to milk her cow around 1910. Each family with children was obliged to keep up its own cow, which might provide milk for as long as six months after calving. Local farmers rented such cows on a rotating basis, trading one that had "dried up" for one that was "fresh." (MW.)

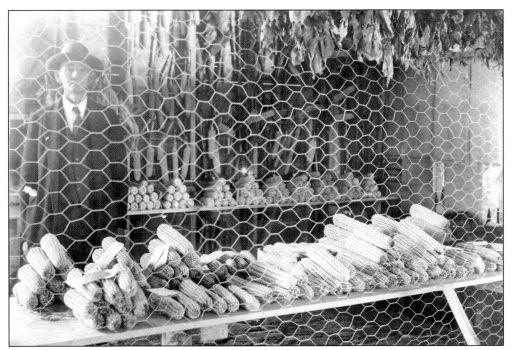

An agricultural display of corn, grown by Troy Redding of Flint Hill around 1915, is shown at the Randolph County Fair. A county fair was first held in the 1850s and continued on and off for more than 100 years.

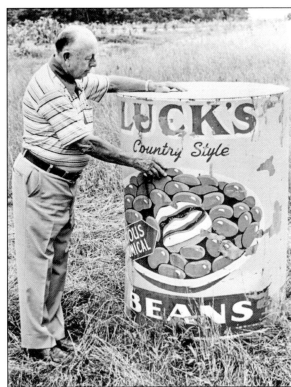

Ivey B. Luck, Alfred Spencer, and others founded the Mountain View Cannery at Seagrove in the 1940s; Luck stands here with his trademark product—Luck's "Country Style" beans, cooked with a piece of fatback pork.

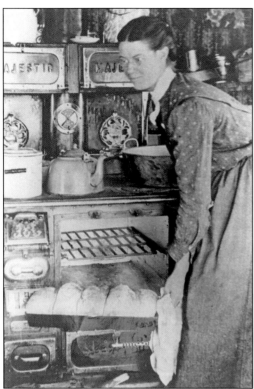

Mettie Macon Lowe (Mrs. Walter Lowe) pulls five loaves of bread out of her Majestic wood-fired kitchen range around 1920. Loaf bread, biscuits, and pancakes became increasingly popular to local tastes after the invention of the roller milling process in the 1870s made fine white flour cheaply available for baking.

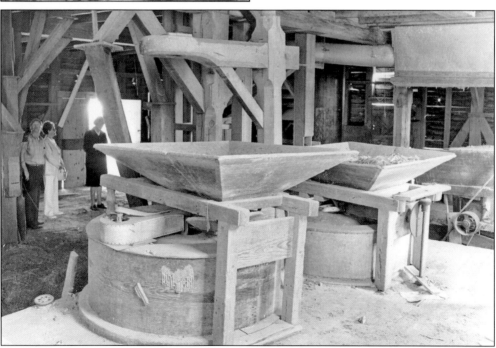

The 1978 interior view of Miller's Mill shows the two sets of stones used to grind grain and corn. Almost every mill built before 1890 would have had a grinding floor, which looked similar to this. The mill burned not long after this photograph was taken.

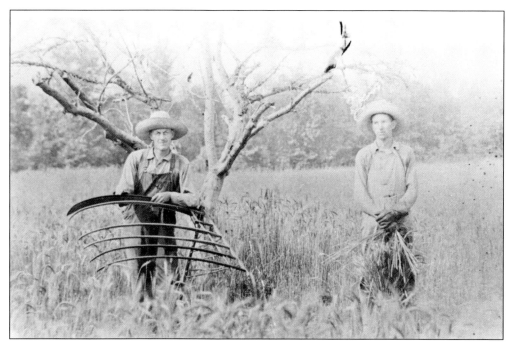

This farmer, posing with his wheat cradle around 1910, was in the process of harvesting his wheat. He would cut and stack the wheat with his cradle, and his companion would tie the wheat into sheaves to dry. Later the sheaves would be gathered and stacked before winnowing the wheat grains from the straw would be done on the threshing floor of the barn. Threshing was usually a good excuse for a neighborhood social.

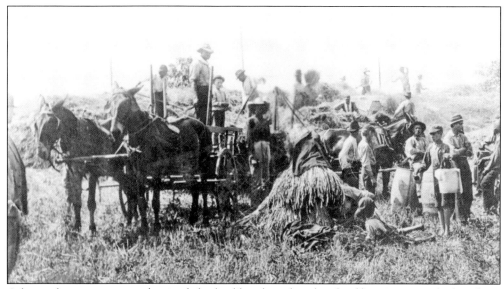

A horse-drawn reaper mechanized the backbreaking handwork of harvesting with the wheat cradle, but gathering and stacking the sheaves was still a group job.

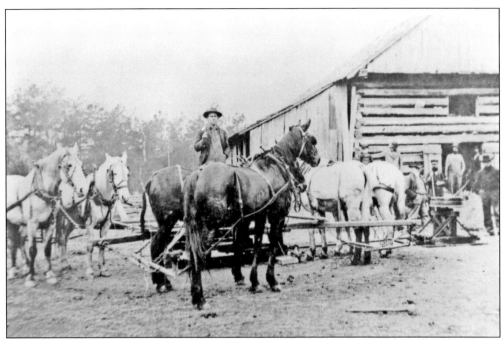

Threshing might still be done in the barn, but a "horse power" like this replaced the need for men and boys swinging flails to knock the grain out of the seed head.

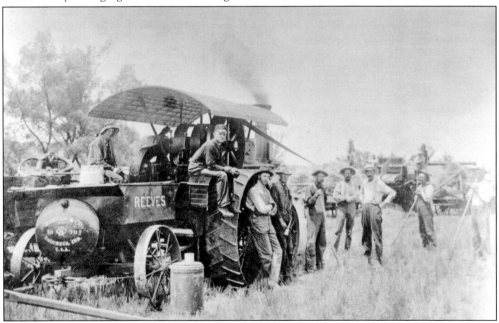

By the 1900s, threshing had been completely mechanized. About 1900, this self-propelled Reeves steam traction engine near Liberty could handle threshing for an entire community. It powered the threshing machine in the distance through a long, leather belt. Two men were needed to feed coal and water from the tender into the boiler. The other seven pictured were forking wheat sheaves into the thresher, bagging the wheat, or building the haystack left when the chaff was sprayed out of the thresher. The bagged wheat was then ready for the mill.

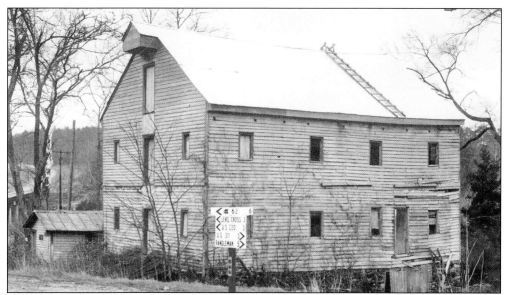

This picture of Walker's Mill located on Muddy Creek near its junction with Deep River in New Market township was taken just before it was demolished around 1965. The site is now under the Randleman Lake reservoir. This particular building was constructed by Samuel Walker, probably in the 1820s, and would have been called a merchant mill, because it had multiple stones grinding grain, as well as processing equipment to further refine the flour. Sliding wooden shutters (instead of windows) and the "lucam" above the loading doors were standard features of mills at the time. In 1781, the mill at this site was owned and operated by William Bell, who was also the Randolph County sheriff. Bell's Mill was the rear headquarters of General Cornwallis during the Battle of Guilford Courthouse, and his British forces spent several days here after the conflict.

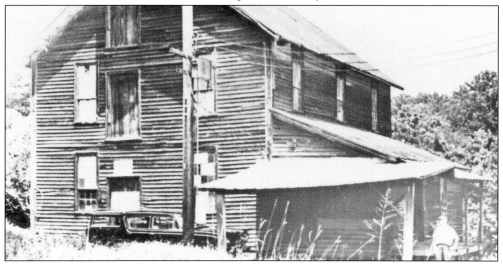

About 2 miles down Deep River from Bell's Mill was the mill built by Peter Dicks of New Salem before 1770. It originally stood in what is now downtown Randleman and after 1848 shared its site and waterpower with the Union Manufacturing Company cotton mill. When the Naomi mill was built in the 1880s, the gristmill was moved about half a mile downstream to avoid the backwater caused by the new textile mill. It had a cotton gin and oil mill in addition to wheat and corn grinding stones.

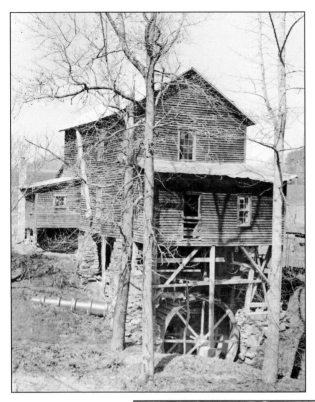

Allison Beane built this mill in the early 20th century on Mill Creek in Columbia township. Still in place under the mill is a steel overshot wheel made by the Fitz Water Wheel Company of Hanover, Pennsylvania, which was said to be 90 percent efficient in its conversion of the flowing water to mechanical power. After 1945, the operation was converted by Raymond Cox to grind animal feed with diesel power. The mill stands just upstream from the site of an 18th-century mill built by Thomas Cox, son of William Cox. Across Deep River, on Millstone Creek, was the mill of Harmon Cox, another son of William Cox. The two Cox's Mills were the center of the territory controlled by Tory guerrilla leader Col. David Fanning in the latter part of the Revolutionary War.

Parker's Mill on the Uwharrie River in Concord township is shown here around 1940. It has since been replaced by the City of Asheboro's Lake Reese reservoir. Parker's mill was run by a turbine waterwheel enclosed in the wooden penstock in the lower left corner of the photograph. A leather belt wrapped around a pulley on the end of the spinning turbine shaft went under the mill and turned the shafts powering the grinding stones.

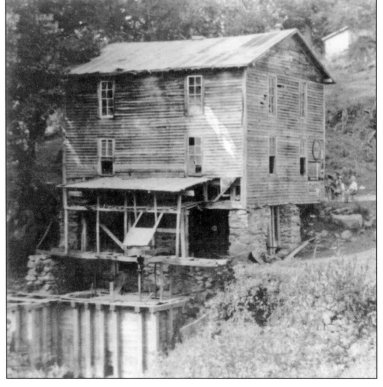

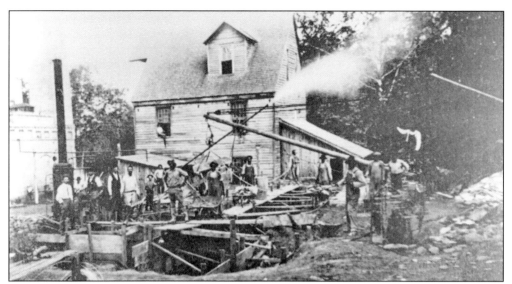

Flour milling is Franklinville's oldest activity, and the mill shown here may have been built by Christian Moretz as early as 1801. It took the name Elisha Coffin's Mill after being remodeled several times and was converted into a roller mill in the 1890s. At the time of this photograph (1912), it was in the process of being replaced by a new three-story wooden roller mill. The Dainty Biscuit self-rising flour, which was produced in the mill, was one of the most popular flours in the state for baking biscuits (originally used for all Biscuitville products) and pancakes (featured at the Asheboro Kiwanis Club pancake suppers for more than 30 years). The mill was the last commercial flour mill in the county when it closed in 1987.

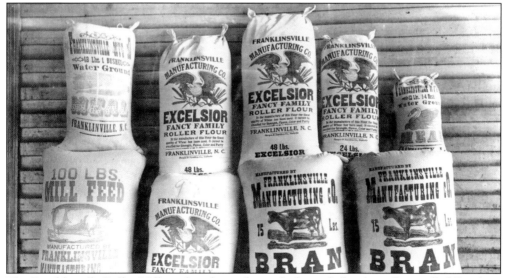

The Franklinville Roller Mill produced a traditional white whole wheat flour called Excelsior Fancy Family Roller Flour. Illustrated here are the products available in 1915: 12- and 48-pound bags of corn meal and 24-, 48-, and 98-pound bags of white flour. The 100-pound sacks of bran were for animal feed. In the 1920s, the mill began to produce a self-rising flour, premixed with baking soda. The name Dainty Biscuit Flour, at the time, would have been a marker of quality: Dainty biscuits were served at tea parties and church socials and were the opposite of large, bulky Cat Head biscuits made for working men's breakfasts. (MW.)

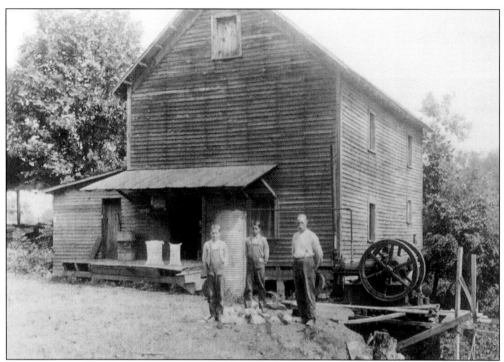

This photograph of Yow's Mill on Fork Creek near Seagrove shows miller Elisha Randolph ("Dolph") Yow and his sons Harvey Roscoe Yow and Walter Elisha Yow. There was a mill on this site as early as 1820, powered by an overshot waterwheel, and the dam is still standing. But at the time of this c. 1920 photograph, an oil engine (run by kerosene, gasoline, or diesel fuel) provided the power.

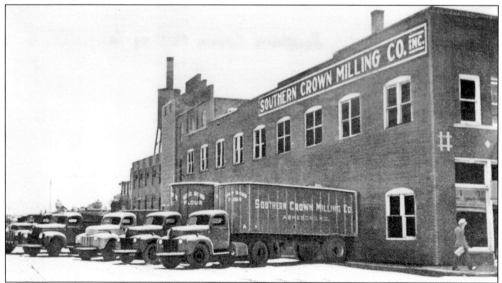

Dr. J. M. Worth founded the Asheboro Roller Mill in the 1890s, which later merged with other companies to form Southern Crown Milling Company in downtown Asheboro. The mill became the largest milling operation in the county and was operated by the W. Frank Redding family until 1958, when the mill burned.

The Ramseur Milling Company was built around 1900 in downtown Ramseur and was almost identical in size and shape to Miller's Mill in Trinity township. It originally produced its own brands of flour and cornmeal for sale to local bakers but by the 1950s was exclusively used for grinding feed for animals. It was demolished in the 1980s.

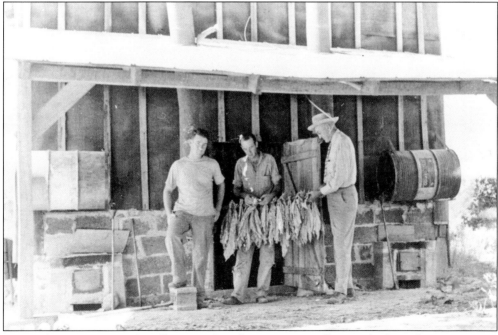

County farm agent Ewing S. Millsaps stands at the entrance to a flue-cured tobacco barn, inspecting the farmers' progress in drying the leaves. Neither cotton nor tobacco were ever substantial cash crops in Randolph County, but after the Civil War, the invention of the flue-curing progress caused tobacco culture to spread widely through the state. There are still small allotments of tobacco grown in the county.

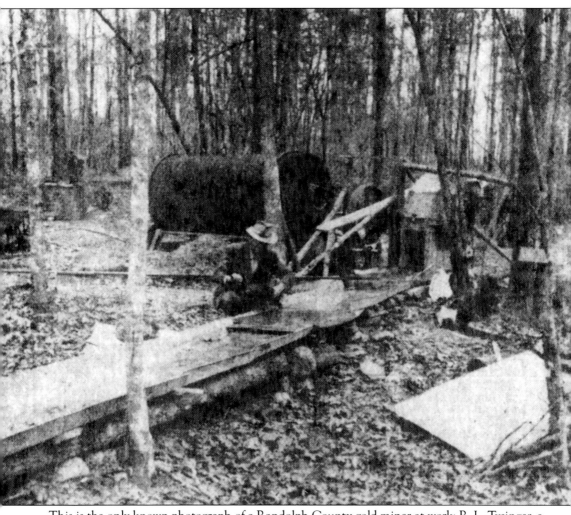

This is the only known photograph of a Randolph County gold miner at work: R. L. Tysinger, a 74-year-old prospector, works at Sawyer's mine on the Flint Hill Road. In the background is an ore washer, which Tysinger said would handle up to 3 tons of ore per day. The county's first gold mine was at Hoover Hill, discovered by Joseph Hoover in 1848. The Sawyer mine was opened before 1856, and one of its seven shafts was as deep as 150 feet. It was sporadically worked until the 1960s. (Credited "Photo by Cole of Arden Studios," this was published in the *Courier Tribune* of March 26, 1951.)

Three

A Place to Make a Living

Randolph County hands have always found ways to make a living, over and above agricultural production. And those busy Randolph hands did more than just make things, they sold them too. Keeping store, in town and county, has roots in the earliest times. Ridge's Trading Post, run by Godfrey Ridge on Ridge's Mountain near the site of the Keyauwee village, was one of the first way stations built by any Colonial settler. Since a store, whether large or small, went hand-in-hand with a mill as a harbinger of urban development, it is little wonder that Randolph was a county of stores, of mills, and later, one with more municipalities, than most of the rest of North Carolina. The census of 1810 found 1,333 hand looms, 400 spindles, and 14 spinning frames that produced 86,000 yards of handwoven cotton cloth worth some $34,000—little wonder that the county also became one of the pioneers of the Southern cotton textile industry, with five mills built along Deep River before the Civil War and eight more after 1880. The county also pioneered industrialization of woodworking and hosiery production, building a base of industrial expertise that lasted into the 21st century.

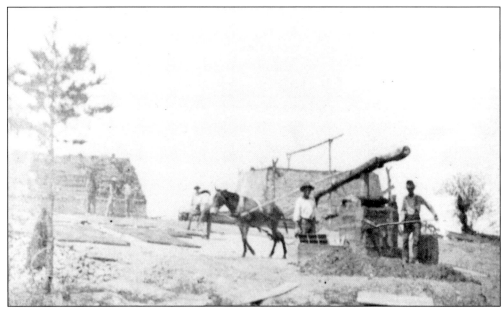

Randolph County red clay was not only perfect for pottery but also for brick making. Either use of clay required that it be ground to remove impurities; that was the purpose of this Pug Mill at the brickyard in Franklinville around 1895. The pyramidal "clamps," or kilns to fire the soft bricks, are in the background. Before the arrival of the railroads, all brick was made locally. (MW.)

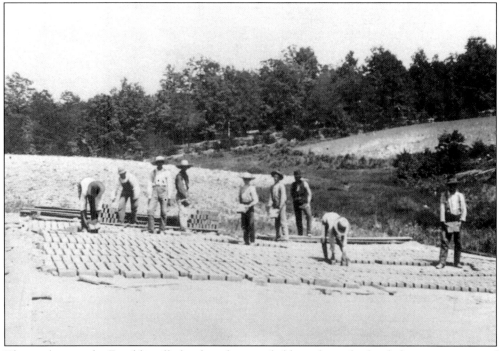

The workers in the Franklinville brickyard are probably making the brick for construction of the Randolph Manufacturing Company, which replaced the old wooden Island Ford mill in 1895. Another county brickyard, in Glenola, made all the red common brick used in the 1909 courthouse. (MW.)

Dorothy Cole Auman, a native of Moore County, was part of a long family tradition of potters from the region of Staffordshire, England. Randolph County has been a center of pottery production in the North Carolina Piedmont for more than 200 years, thanks to the extensive sources of clay. "Dot" Auman was an operator of Seagrove Pottery and a founder of the Seagrove Pottery Museum, which she installed in the former Seagrove train depot. Her collection is now part of the Mint Museum in Charlotte.

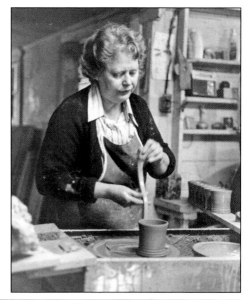

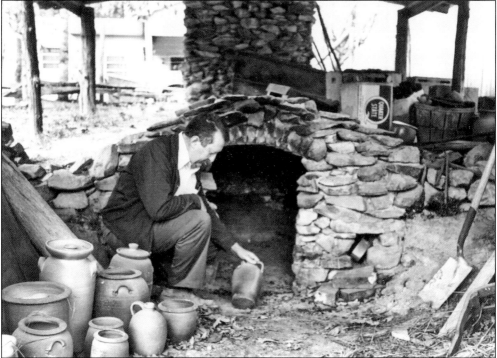

Walter S. Auman (1926–1991), husband of Dorothy Cole Auman, stacks pottery inside of a traditional "Ground Hog" kiln, a long, narrow firebox dug into a sloping bank. Traditional potters were farmers first and potters second, usually turning pottery during slack times of the spring and summer, and firing kilns with wood during the fall and winter. When a kiln had been fired and was ready to sell, potters would often load a wagon and travel into eastern North Carolina to sell the ware. During the late 19th century, when cheap, mass-produced "china" was flooding even the Southern market, potters made a living by turning gallon, 10-quart, and 5-gallon jugs for moonshine whiskey.

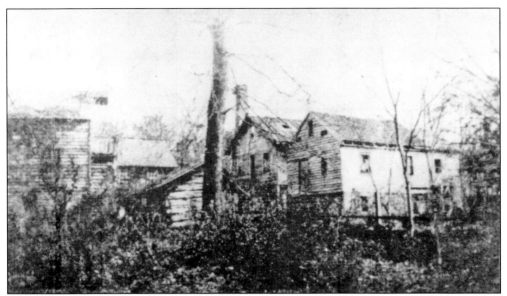

The Bush Hill Steam Tannery was founded by Allen U. Tomlinson in 1825; it operated until 1900. Lye, oak bark, urine, animal feces, and decaying flesh made tanneries a smelly and toxic stew, but the community prospered by using the leather for the manufacture of shoes, saddles, and other goods. It was settled as Bush Hill in 1786 by Quakers who migrated from Bush River, South Carolina. The town was renamed Archdale in 1887 in honor of John Archdale, the first Quaker governor of North Carolina. (MW.)

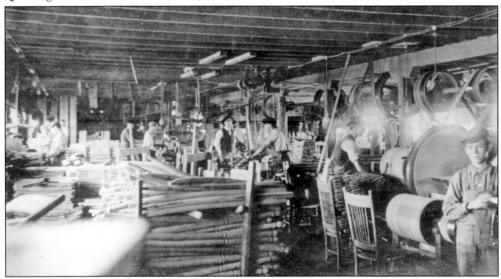

This is the Randleman Chair Factory around 1910; like every 19th-century factory, it was a web of spinning overhead shafts, pulleys, and belts. The factory was located next door to the Randleman School. Rich in lumber and forest resources, Randolph County has been a source of furniture manufacturing since the 1870s. The first market for wood products grew out of the local cotton mills—bobbins for spinning frames, shuttles, and picker sticks for looms. The primary reason that railroads were built through the county in the 1880s was to open up the county's market for lumber, and manufacture of items such as axe handles, wagon wheels, and chairs was the next logical step. (MW.)

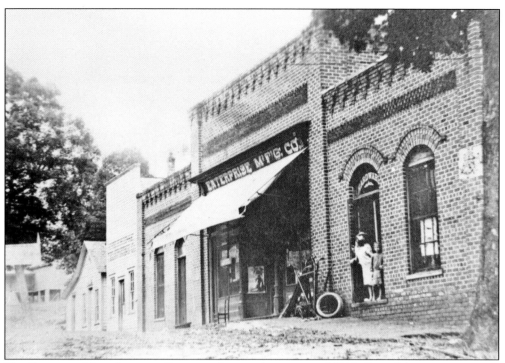

The Enterprise Manufacturing Company Store is shown around 1920. One of the most important aspects of any factory and mill village was its company store, which advanced credit to employees secured by their future earnings. The brick store building still stands, but the wooden boomtown storefronts have disappeared.

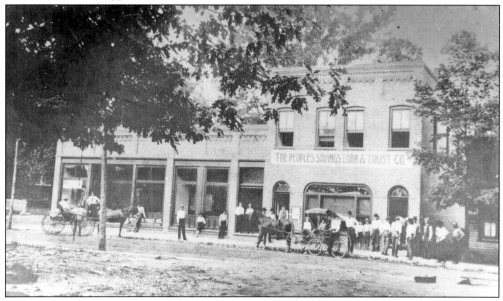

Main Street in Randleman is viewed around 1914. The single-story building is the Arch Millikan Store; in the center is the post office. The two-story building houses the Peoples Savings, Loan, and Trust Company. There were also company stores in the several mill villages that grew together to form Randleman.

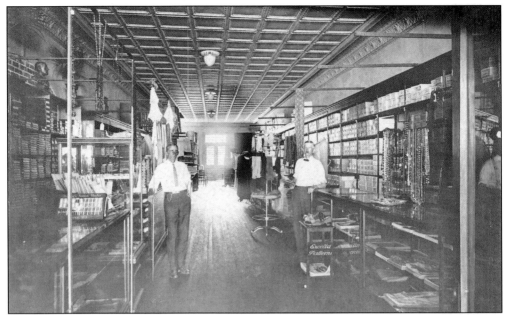

Wood and Moring's, a purveyor of clothing and dry goods, was located at the corner of Fayetteville Street and Sunset Avenue in Asheboro and is shown here in 1906. Founded in 1880 as W. P. Wood and Company, partner W. H. Moring moved it to this corner, next to his home, in 1895. It moved to a brick storefront on Sunset in 1920 and sold out to the Hudson Belk chain in 1929. John Wood (left) and William Henry Moring (right) are shown inside their store.

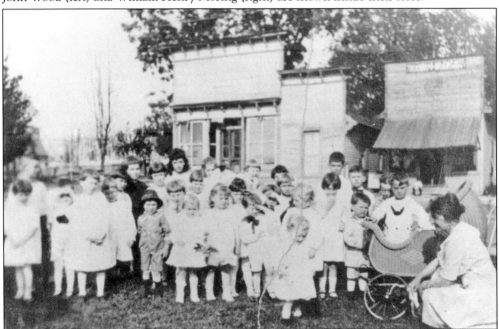

Children celebrate at the birthday party of Cornelia Hunt Hedrick (Mrs. W. P. Wood Jr.) around 1920. Buildings in background are on Fayetteville Street near Cranford Street; from left to right, they are Miss Eugenia Tysor's Millinery Shop, the telephone office, and Bett's Meat Market. (Courtesy of Arthur Burkhead album.)

The A&P was the first national chain store to be located in Asheboro, at 105 Sunset Avenue, around 1930. Everett Walton was the manager; Jesse Tyson and Z. L. Keever are two of the customers.

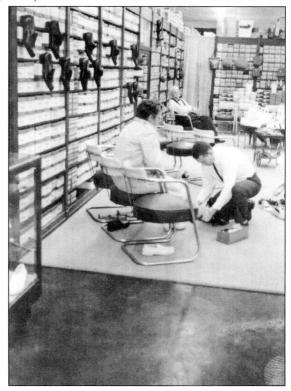

The Coffin-Scarboro Company opened in 1915, selling men's clothing and shoes. By the time of this photograph in 1960, it had converted solely to selling shoes. Sitting in the chair in the background is owner Harris A. Coffin, grandson of Elisha Coffin, the founder of Franklinville.

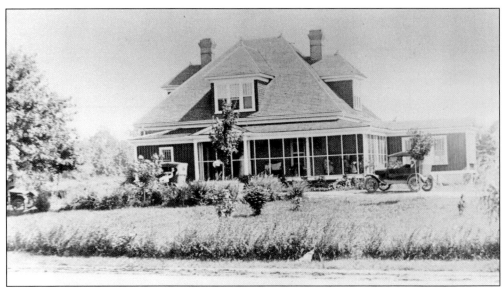

One of the first hospitals in the county was located in New Market township, on the north side of Highway 311 between Randleman and Sophia. Dr. Charles Edgar Wilkerson started the hospital; his wife, Lula Phillips Wilkerson, served as head nurse and anesthetist. The brick building had running water, electric power, and an operating room. The distinctive roof was subsequently lost in a fire, but much of the structure still stands, remodeled into a house.

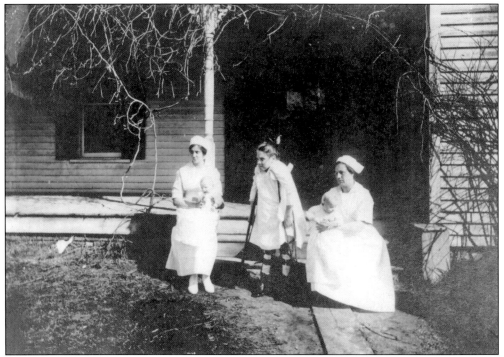

The first hospital in Asheboro was started in the former J. W. Teague residence on North Fayetteville Street, adjoining the Red Star service station at the corner with Salisbury Street. The nurses, Miss Hyatt and Miss Bailey, pose with two babies and a polio patient. Dr. Miller opened the hospital in 1915, with his wife as staff.

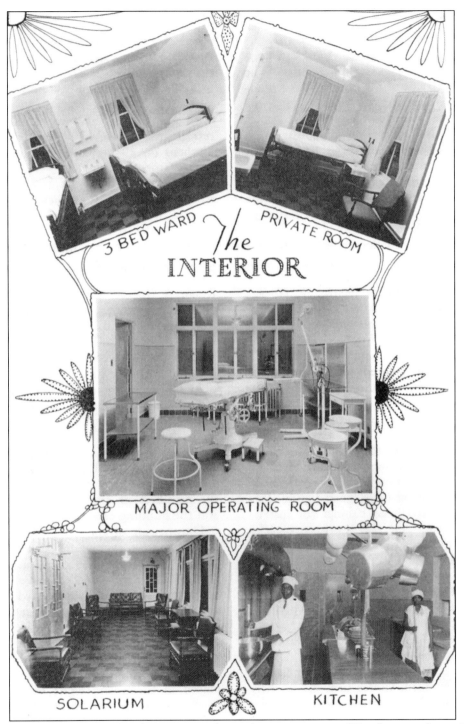

3 BED WARD
PRIVATE ROOM

The INTERIOR

MAJOR OPERATING ROOM

SOLARIUM
KITCHEN

Randolph Hospital, completed in 1932, was the art deco masterpiece of Henderson architect Eric Flannagan. The facility boasted 39 beds, with a separate ward for black patients on the ground floor near the emergency room, which was entered under the stairs. This early brochure illustrates not only the patient accommodations but also the operating room and kitchen.

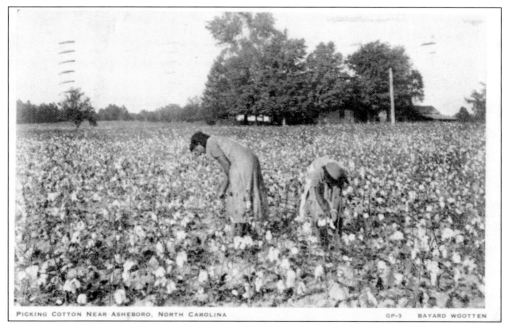

PICKING COTTON NEAR ASHEBORO, NORTH CAROLINA GP-3 BAYARD WOOTTEN

Two women are "Picking Cotton Near Asheboro, North Carolina." Local cotton mills needed all the cotton they could get, but there was really very little cotton grown in Randolph County. One of the most interesting aspects of this postcard photo is its photographer. Bayard Wootten (1875–1959) was a pioneer female photographer who worked all over the South. Many of her prints and negatives are housed in the Library of Congress.

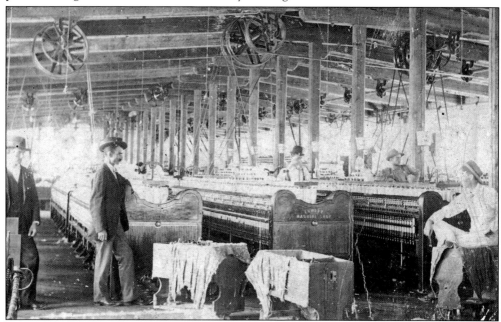

This is the spinning room of the Randolph Manufacturing Company, formerly the "Island Ford" mill in Franklinville, around 1900. Spinning room foreman Henry Jones is standing second from left. The original mill on Deep River, started in the Elliott gristmill at Cedar Falls in 1836, had spinning frames to make bundle yarn for hand weavers. (MW.)

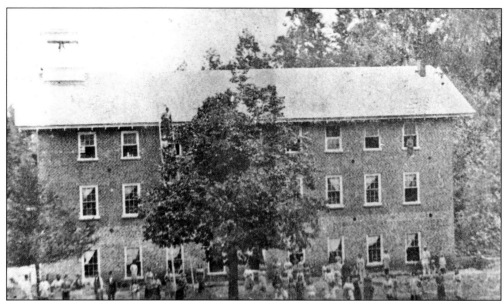

This is the Franklinsville Manufacturing Company from the west. Taken in 1874, this is the earliest known photograph of a county textile mill. At least 47 employees are visible in and around the building. The appearance of the factory is as it was rebuilt after the fire of 1851, which destroyed the upper stories. The original factory probably looked much the same as the nearby Island Ford mill; the lighter-colored brick at the first floor level indicate the original walls were built in 1838. (MW.)

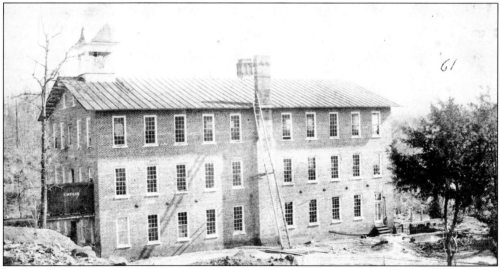

This photograph of the factory of the Columbia Manufacturing Company was taken in April 1886 for the South-Eastern Tariff Association, a factory mutual insurance company. The view is of the north side of the original 1850 building, largely covered by later additions. The head race is to the right at ground level; the covered ramp at the left is where cotton laps were brought from the picker house into the carding room on the second floor. Spinning would have been on the third floor and weaving on the first. The exterior chimneys were probably for heating stoves on each floor but could also have served as flues for the starch or "size" kettles in the slasher room, needed for weaving. (Courtesy of Wally Jarrell.)

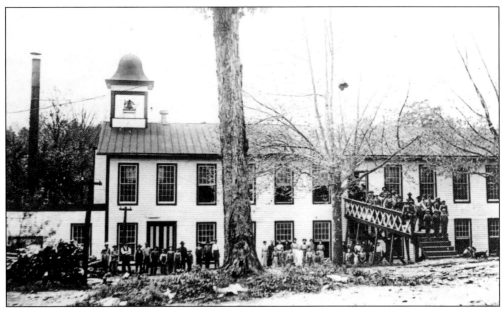

The original Enterprise Manufacturing Company was a two-story wooden mill built in 1882. It was torn down in the 1920s to build the mill that stands today. The Cotton Mill Campaign of the early 1880s built hundreds of cotton mills across the South. Between 1881 and 1895, it added eight new cotton factories to the five antebellum mills the county already had on Deep River.

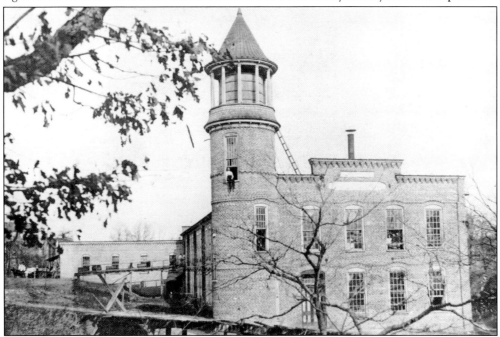

The Mary Antoinette Mill was one of the most impressive of the late-19th-century mills. Organizer John H. Ferree named the mill after his daughters, not after the famous French queen. It operated from 1895 to 1936, when it housed Pinehurst Frocks and Randolph Lingerie, an early cut-and-sew apparel business. In 1944, it became the Scheierson Manufacturing Company; in 1970 that company merged with Kayser-Roth Hosiery Corporation.

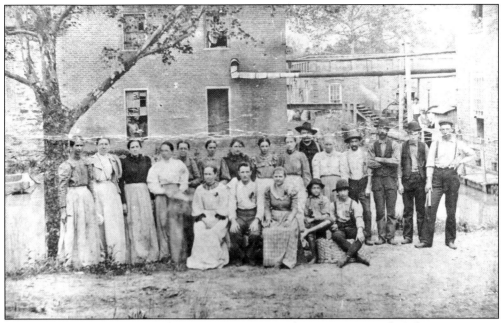

Pictured is a Randleman Manufacturing Company employee group around 1895.

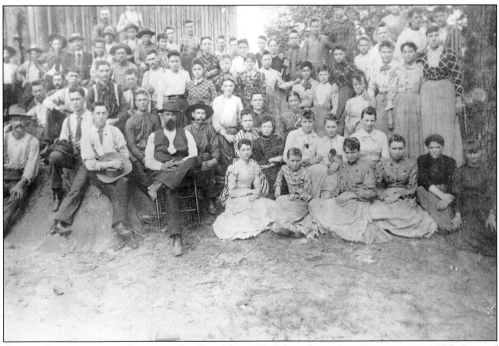

An employee group is shown at the Franklinsville Manufacturing Company in 1895. One of the most popular textbooks on Southern cotton mill village life is the UNC Press book *Like A Family*, which includes many oral history interviews with North Carolina textile workers. These photographs of mill workers from Randleman and Franklinville, both taken around 1895, give a sense that the paternalistic control of mill village life was not as restrictive as it sounds.

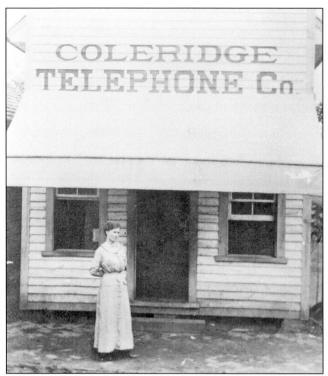

Mill owner R. L. Caveness established Coleridge Telephone Company in 1919. The county's first telephone company was founded in Asheboro in 1897; it had rural connections to Cedar Falls and Franklinville. Randleman formed a company in 1900; Ramseur and Liberty both opened service in 1907.

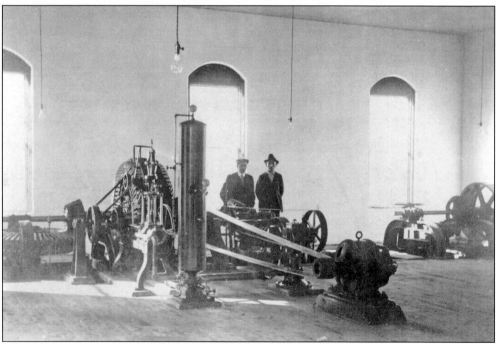

Shown is the Enterprise Manufacturing Company powerhouse in 1925. Two turbines are connected to a dynamo, which is generating electricity to run the mill. The county's first electric lights were installed in the factory in Franklinville in 1896. Asheboro residents received electric lights in 1905, Randleman in 1909, Ramseur in 1911, and Liberty in 1916.

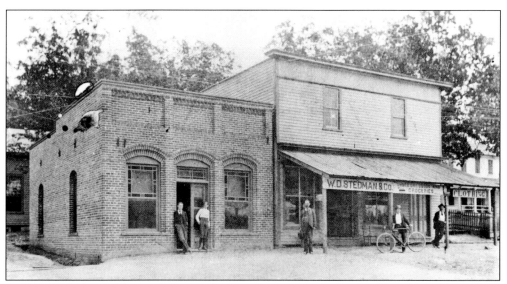

In 1898, W. J. Armfield started the first bank in the county, the Bank of Randolph. Shown here around 1900, it faced west down Sunset Avenue where the entrance to its successor, Wachovia Bank, is today. W. D. Stedman moved to Asheboro in 1889 from Mount Gilead in Montgomery County to build this grocery store. Around 1908, Stedman moved his store to a new location on Depot Street adjoining the railroad tracks, and he gradually expanded into owning an automobile dealership, another bank, and a handkerchief factory.

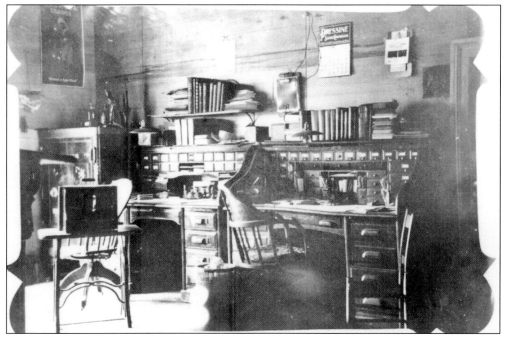

The late 19th century saw the rise of modern office work. Hugh Parks's office, at the Lower Mill (Randolph Manufacturing Company) in Franklinville, still seems like an acceptable workplace to 21st-century eyes. According to a note in the *Courier* newspaper of February 18, 1904, Parks purchased two of the first typewriting machines in the county for use in the mill offices. The case for one is seen on the table to the left. (MW.)

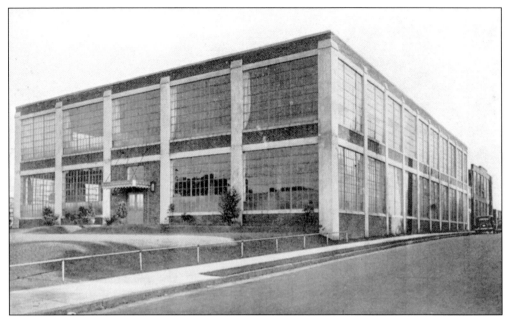

McCrary Hosiery Mills was organized in 1927 just to manufacture "full-fashioned" women's hosiery. Mill No. 2, built around 1930, is a local example of the influence of industrial architect Albert Kahn, whose factories were the first to use reinforced concrete structural construction and steel sash, allowing large expanses of glass curtain walls to provide a maximum use of natural light. Ironically, the windows were very soon bricked up.

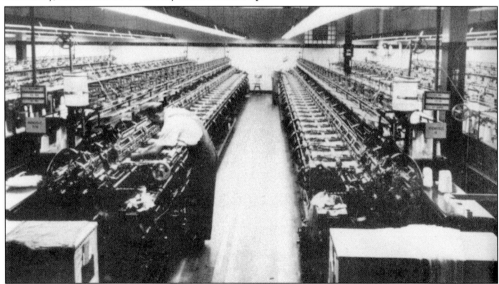

The first hosiery mill in the county began operation in Randleman in the early 1890s. Asheboro and Randleman gradually became identified with hosiery manufacturing. Full-fashioned women's hosiery machines, seen here at a McCrary mill around 1935, were the most valuable hosiery product. Knitted with silk to the full-fashioned contours of a woman's leg, the hose were finished with a seam sewn up the back and were a symbol of status and sophistication for any well-dressed woman. Manufacturing switched over from silk to nylon in 1938, but in 1967, full-fashioned knitting was discontinued, and the separate Acme and McCrary mill companies merged.

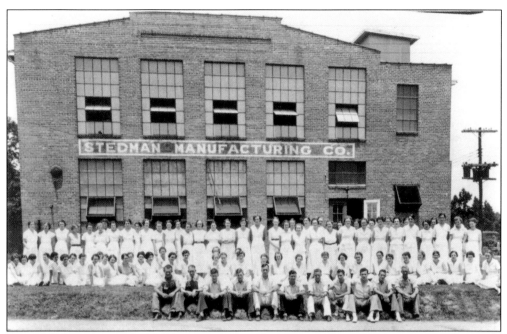

Employees of the Stedman Manufacturing Company are in front of their mill around 1940. S. B. Stedman and his father first invested in a factory to cut and sew handkerchiefs; they expanded into making T-shirts for the U.S. Navy during World War II, which ultimately grew into Stedman Manufacturing Company, makers of knit goods and men's underwear. They moved from this mill on Hoover Street into a larger facility on South Fayetteville Street in 1946.

This is an aerial view of the General Electric Plant, located at 1758 South Fayetteville Street in Asheboro. Built around 1939 as Lucas Industries, a furniture manufacturer, General Electric took over the factory in the 1950s, reengineering it to make electric blankets, toasters, and other consumer products. The site had formerly been the county fairgrounds, and before that, the location of a gold mine.

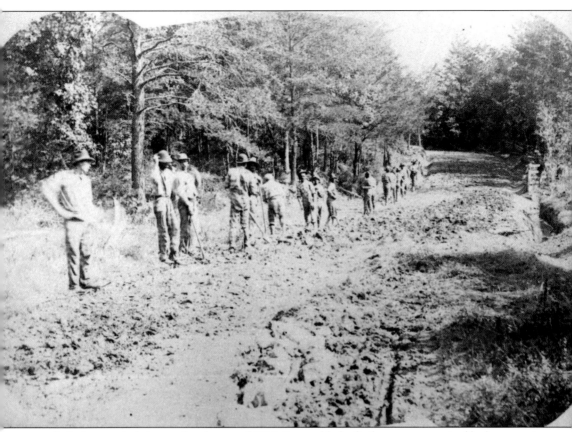

A chain gang is doing roadwork around 1915. Every able-bodied man was required by law to assist in the maintenance of roads serving his property. If he could not do it himself, he was required to hire a substitute or send slave labor. In the late 19th and early 20th centuries, convict labor was used when available. The picture graphically illustrates the quagmire that was a relatively well-maintained local road. (MW.)

Four

TRADING PLACES

Transportation is the vital link between product and market. When a farmer grew more than he needed to eat or feed his animals, he could sell the surplus—that is if he could get it where someone needed what he had to sell. Road maintenance was a function of county government until 1934. Until then, local property owners were required to assemble regularly with their neighbors to repair and rebuild the area's muddy dirt roads. The slow pace of travel required overnight accommodations, food, and lodging, for both man and animal. Improvement of transportation was one of the first expansions of governmental expenditures, as internal improvements had a positive effect on the prosperity of citizens. The Fayetteville and Western Plank Road, built diagonally through the county in 1851, was a partnership between state government and private investors. Despite its brief life span, it showed county residents what a good, all-weather road could do for the economy. In the 1880s, railroads were built to tap into the county's forest resources—the High Point, Randleman, Asheboro, and Southern coming down from Guilford County; the Aberdeen and Asheboro coming up from Montgomery County; and the Cape Fear and Yadkin Valley sending a spur down from Julian. The county's many watercourses, as useful as they were for waterpower, required all-weather passage . . . fords, open bridges, covered bridges, steel bridges—and now concrete bridges. The landscape of transportation has ever modernized to keep up with the pace of American life and the inability to stay in one place.

Rock Bridge across Little Uwharrie River at Fuller's Mill in 1933 is seen above. A ford was a natural shallow spot where it was possible to cross a creek without drowning pedestrians or animals. Fords could be maintained by adding rock as the stream scoured it out, but a "rock bridge" used timber cribs to create a mini-dam, where rock fill could create a passable crossing.

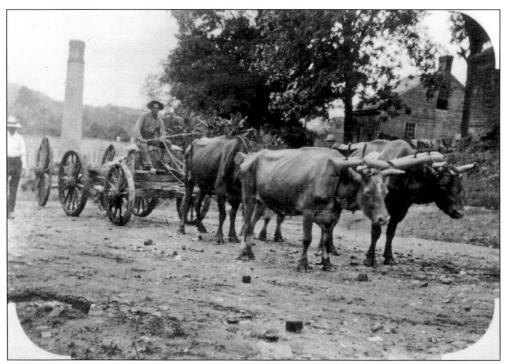

The Randolph Manufacturing Company ox team, around 1910, was used to haul cotton bales and machinery. Trained oxen were ancient draft animals, used in the county up to World War I. They were able to pull heavier loads than most horses and mules. (MW.)

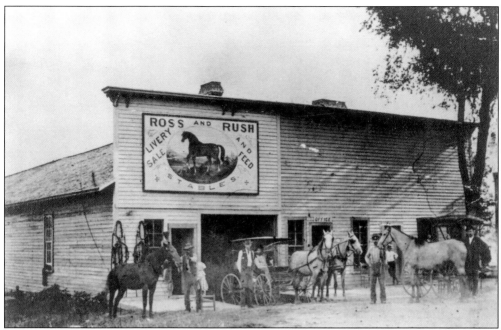

A livery stable run by Rom Ross and Zeb Rush was located at Salisbury and Main Streets, at the northwest corner of the Old Public Square in Asheboro. Until 1920, every town had a livery stable just as today every town has a gas station. A livery stable usually had its blacksmith, as a gas station has a mechanic.

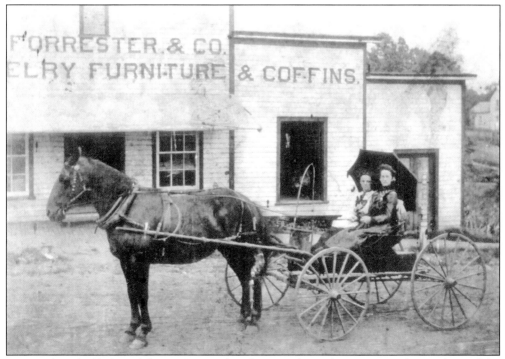

Two unidentified ladies of the 1890s stop their buggy to have their picture taken in front of the J. O. Forrester store in Ramseur.

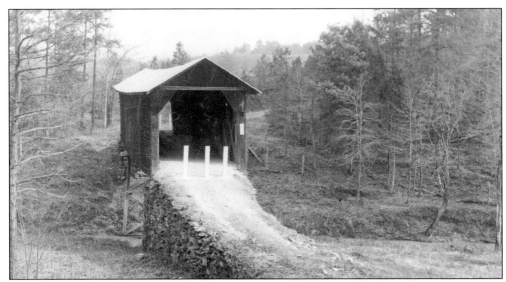

This photograph of Skeen's Mill covered bridge was taken January 26, 1958, before a new bridge was built and the highway was rerouted to bypass this structure. This bridge was built across the Uwharrie River in Tabernacle township in 1900. It collapsed in a 1986 flood. Construction of covered bridges was first authorized by county government in 1844 and became a staple of the local landscape. More than 60 covered bridges existed in the early 20th century, and 42 were photographically documented in 1936. The heavily restored Pisgah Bridge, across Little River, is the only survivor.

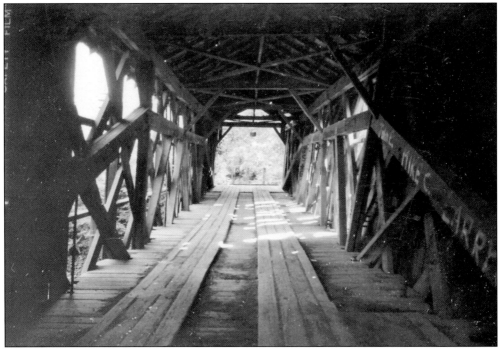

The interior of Skeen's Mill covered bridge is seen above. The bridge was 100 feet long and 12 feet wide. It was a single span across the river, 22 feet above the water, with a "queenpost" truss system. The plank treads saved the interior from wagon wheel wear and tear.

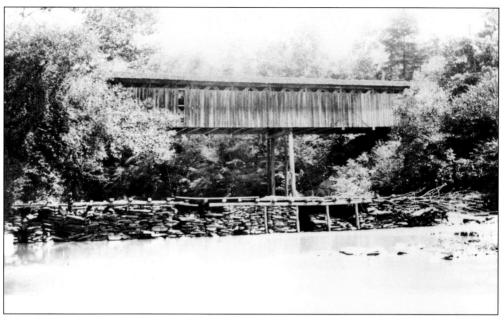

The Burney's Mill covered bridge was built across the Uwharrie River between Seagrove and Pisgah. The dam below the bridge is a classic design using log cribs filled with rocks to impound the water, and the wooden apron across the top raises the water level to increase the head race power. William Burney built his mill on the Uwharrie before 1821.

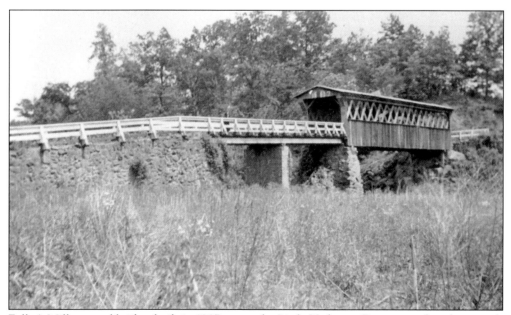

Fuller's Mill covered bridge, built in 1907 across the Little Uwharrie River, is in this photograph taken in 1935. Henry Fuller built his mill near a busy ford of the Uwharrie about 100 years before the construction of the bridge. Methodist bishop Francis Asbury crossed there while circuit riding in 1793; community baptisms took place just upstream from the bridge.

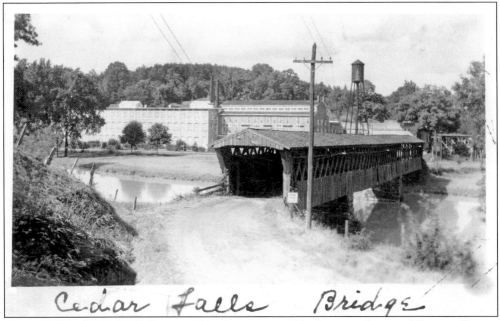

Cedar Falls Bridge

Around 1930, the Cedar Falls covered bridge is pictured looking north toward Sapona Cotton Mill, in the background. This bridge was one of the first authorized and built by the county and was an example of the "Town Lattice Truss," invented for an earlier bridge in North Carolina.

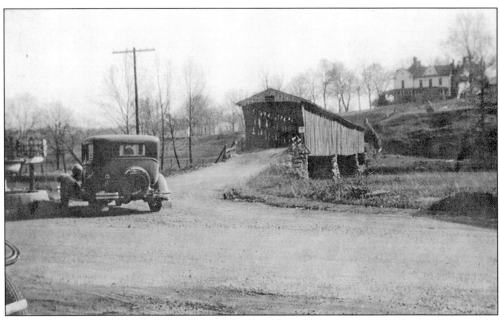

This is the same bridge as above at Cedar Falls, but viewed from a point standing in front of the mill and looking south.

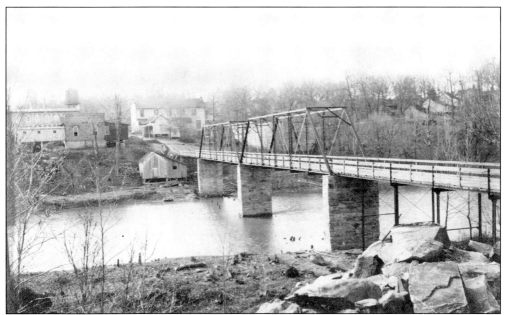

The Worthville steel bridge is over Deep River, looking south toward the cotton mill. Originally called "Hopper's Ford," there were several covered bridges here before the steel bridge, and later concrete bridges. The present-day bridge is a quarter mile downstream from this location. William Dougan was given permission to build a gristmill at Charles Hopper's Ford in 1832; Dr. J. M. Worth and his son-in-law A. C. McAlister built a cotton mill there in 1880.

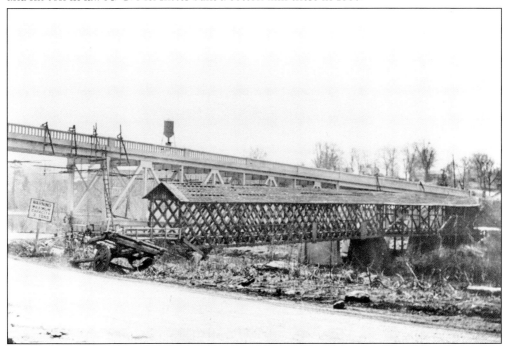

Around 1935, the Central Falls covered bridge is shown with a new highway bridge under construction in the background. The cotton mill at Central Falls was founded in 1881. Purchased by the Worth Manufacturing Company in 1886, it became known as their Mill No. 2.

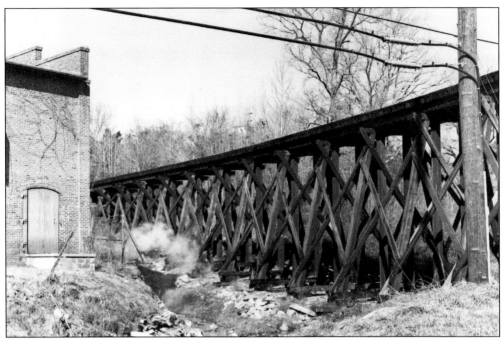

The railroad trestle at Cedar Falls was first built around 1888 and removed in 1985. The "Factory Branch" of the Cape Fear and Yadkin Valley Railway came south from the main line at Julian and ended at a turntable outside the Ramseur factory.

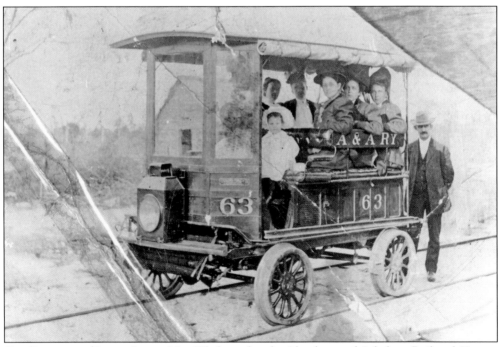

Gasoline-powered inspection car No. 63 belonged to the Aberdeen and Asheboro Railroad. Known members of the Page family on board are J. R. (Chris) Page and his wife, Myrtle McCauley Page; Nettie McCauley Wood (Mrs. John K. Wood); and child, Etta Reid Wood.

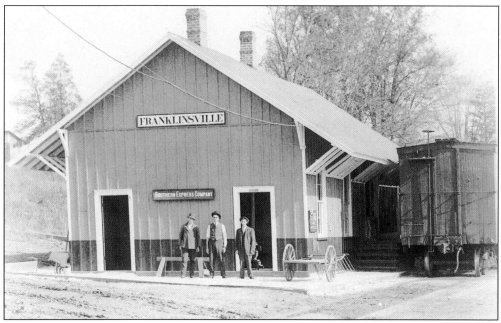

The Franklinville Cape Fear and Yadkin Valley Railway passenger and freight depot measured 23 by 52 feet and was painted yellow and trimmed in green. The freight section was built in 1894, but the passenger station was added in 1914. (MW.)

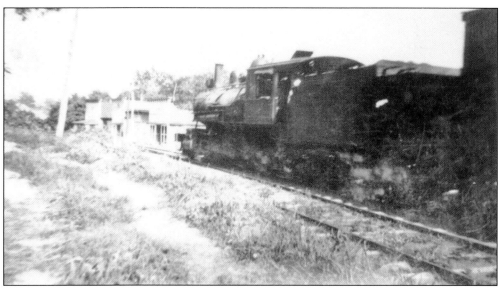

A train is passing the old Franklinville riverfront business district on River Road in Franklinville around 1920. It came through town daily around noon and again after it turned around in Ramseur. All of the wooden storefronts were destroyed by flood or fire before 1950. (MW.)

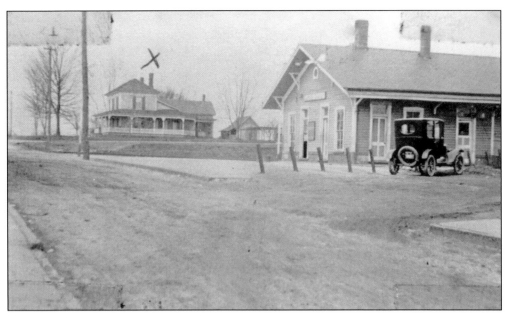

The High Point, Randleman, Asheboro, and Southern Railway was built south to Asheboro in 1888 and 1889. The Randleman Depot, shown here around 1930, was located on a dead end spur track into the center of town.

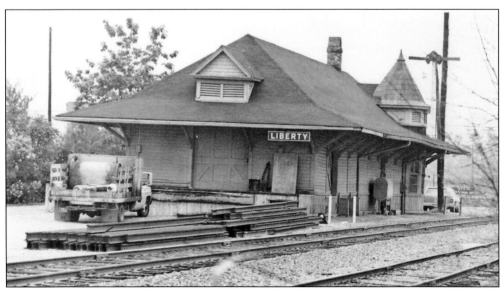

The Liberty Depot, shown here around 1970, was on the main line of the Cape Fear and Yadkin Valley Railway, which was built in the early 1880s to connect the granite quarry at Mount Airy with the shipping point and Fayetteville. The "Factory Branch" of the railroad connected the main line south from Climax to a turntable at Ramseur.

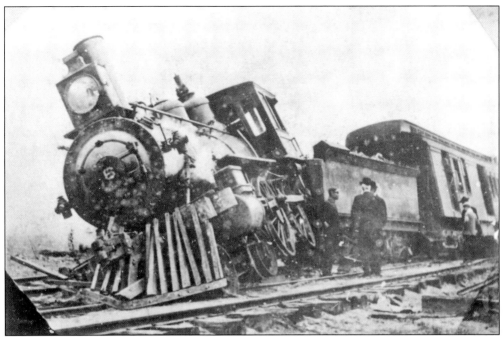

Pictured is a train wreck below Seagrove in 1898. This is thought to be "The Vestibule," the nickname of the daily A&A train that came up from Aberdeen to Asheboro at 11:00 a.m. and then went on to High Point and came back around 3:30 p.m.

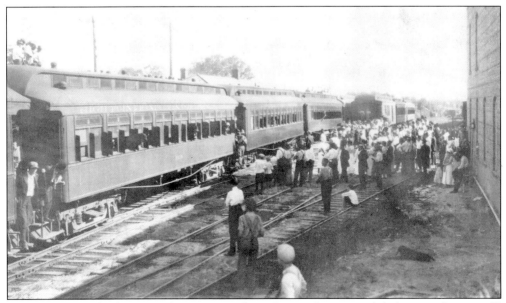

Pullman cars are loading near the passenger depot Sunset Avenue in Asheboro, as Company K soldiers leave for Camp Sevier in Greenville, South Carolina, in 1917.

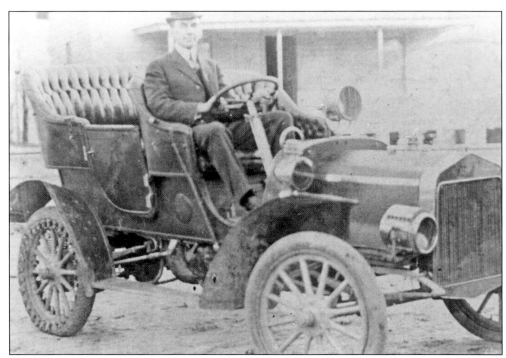

Col. James Edward Williams is driving his new Maxwell automobile in Worthville in 1909. By 1914, there were at least three Maxwells in the county, and 60,000 had been sold nationwide. The company was absorbed by Chrysler in 1925.

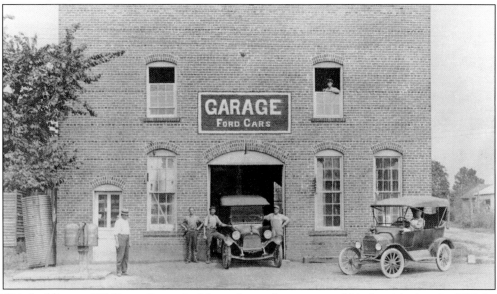

This building at 134 Depot Street in Liberty housed a wagon and blacksmith shop in 1911. In 1916, Charles P. Smith Jr. organized the Smith Motor Company, a Ford dealership. Railcar loads of Model T parts were shipped to here; axles and wheels were added on the spot to the chassis, which was pushed up a ramp to the second floor where the final assembly was completed to customer order. Ford did not ship assembled automobiles to its dealers until after 1923. Randleman native Buzz Freeman acquired the Smith Motor Company in 1971; it now operates as Freeman Ford.

E. S. Thomas, the president of the Franklinville Lions Club, takes a break in 1952 from a car wash to raise money for Franklinville High School's first activity bus. The fund-raiser was held at John Q. Pugh's Esso Service Station in what is now called the Blue Mist area. Pugh, a veteran of the Army Air Corps, opened the service station in 1947 while he continued to work as a fixer at Laughlin Hosiery Mill in Randleman. Pugh's Esso has now expanded to become Pugh Oil Company.

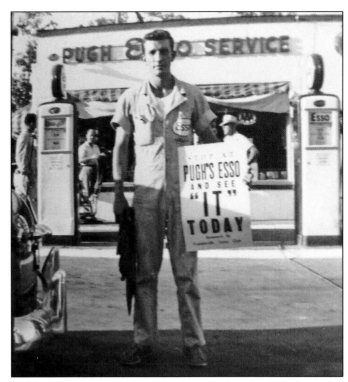

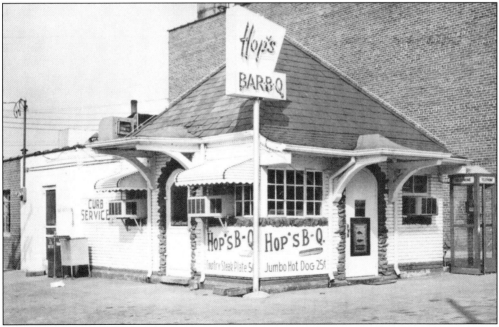

Hop's Bar-B-Q was, and still is, located just to the west of the Sunset Theater at the corner of Church Street and Sunset Avenue in Asheboro. Burrell Hopkins opened and ran what is considered Asheboro's first fast-food restaurant in October 1955. The sit-in that tried to integrate Hop's in 1961 was Asheboro's first battle of the civil rights era; more than two dozen African Americans were arrested in the protest.

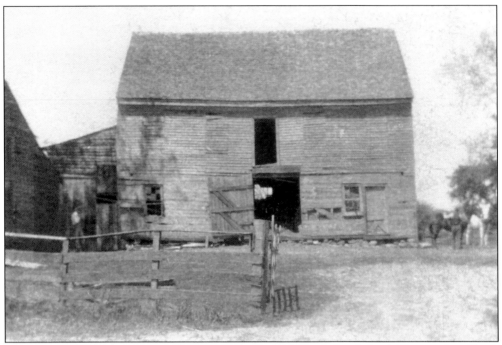

The New Market Inn is on Plank Road in Sophia, near New Market School. The inn dated back at least to the early 19th century; in 1852, it became a tollhouse and stop on the Plank Road. David W. Porter (1823–1882), the father of the author William Sidney Porter (O. Henry), was born here. The photograph was taken in 1935; the building collapsed in 1960.

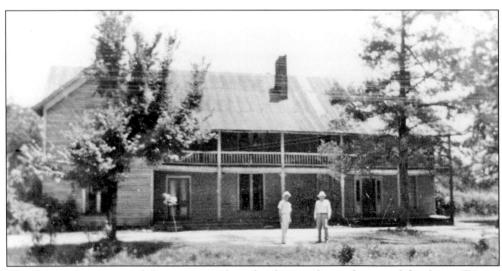

The Trinity Inn is one of the numerous boardinghouses for students and faculty at Trinity College. The college had no dormitories of its own, and both students and faculty lived with local residents.

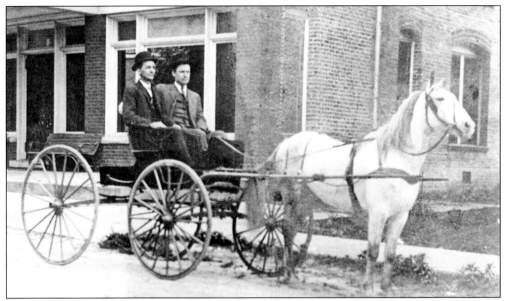

The Ashlyn Hotel at 115 North Fayetteville Street in Asheboro opened September 1, 1911. Local banker W. J. Armfield, who was also chairman of the county commissioners and supervised the construction of the courthouse, built it. E. G. Morris (left) and W. J. Armfield (right) pose on a buggy in front of the hotel about 1915.

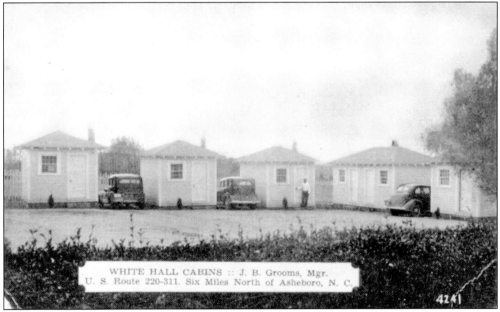

WHITE HALL CABINS :: J. B. Grooms, Mgr.
U. S. Route 220-311. Six Miles North of Asheboro, N. C.

This postcard of the White Hall Tourist Court is dated 1938. The business was located at the intersection of U.S. 220 and U.S. 311 just south of Randleman. In March 1939, two travelers stopping overnight at White Hall were killed when the bottle gas tank supplying their cabin heater exploded. The tourist camp or motor court was a creation of the 1920s, as automobiles began to mobilize America. Tiny individual cabins barely big enough for a bed were grouped so that cars could park between each one. When the phrase "motor court" was conjoined to the word "hotel" in the 1950s, we got a new concept: motels.

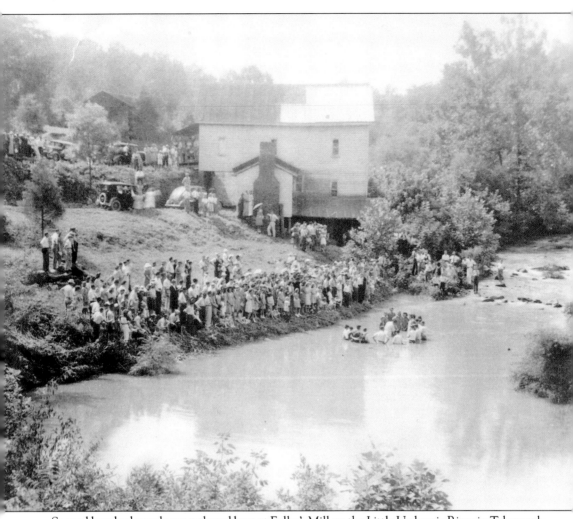

Several hundred people are gathered here at Fuller's Mill on the Little Uwharrie River in Tabernacle township, probably in the mid- to late 1940s. In a community baptism, a number of local churches met to reenact the Biblical story of John the Baptist, who baptized Jesus in the River Jordan (Mark 1: 9–10). Baptism by submersion or partial immersion is one of the iconic rituals of Southern Baptists and related denominations. The mill shown here was probably built in the late 19th century and was demolished in the 1960s. (Courtesy of Worth Younts.)

Five

THE SPIRIT OF A PLACE

Before the late 19th century, most Randolph residents would have made no distinction between religion and education. Many of the pioneer settlers of the county had come to this region of the frontier to free themselves of the restrictions of religious orthodoxy. Quakers were among the first emigrants from Pennsylvania, and these meetings of Friends turned inward, refusing to participate in politics or government and tightly regulating the education and moral conduct of their birthright members. "New Light" Baptists, such as those who followed the Rev. Shubal Stearns to Sandy Creek in 1755, were also escaping from the unfriendly confines of Puritan New England, and their style of missionary zeal would proselytize the expanding southern frontier. Methodists came in the late 18th century, with circuit riding ministers who nurtured far-flung congregations. In 1860, only 18 men identified themselves to the census as ministers—including 11 Methodists, two Lutherans, a Baptist, and a Presbyterian. Quakers, at that time, had no hireling ministers, so their meetings far outnumbered the rest, and even now, Randolph County has more Friends meetings than any other county in the state. Quakers also encouraged a very forward-looking attitude in the county toward education, as they believed both men and women were equally in need of learning in the service of enlightenment. Randolph established local school committees with tax collection powers soon after publicly funded schools were first authorized by the state legislature in 1840. In addition to the one- or two-room public schools, local citizens could charter academies with the legislature and operate them as private school corporations. Academies could provide college preparatory classes or specific training for teachers; some, such as Trinity College (now Duke University), were all three. Private academies began to fade after 1901 when a new system of state school support was established. In the 1920–1921 school year, Randolph County supported 123 rural schoolhouses—104 for white students and 19 for African American students. Only two of those schoolhouses were of brick construction, and 83 of them housed all grades in one classroom. By 1940, the county reduced its population of schools down to 21 buildings by creating a fleet of 65 buses to move pupils around a completely reorganized county-wide school system. Whether church school, public school, or private school, the places that provide moral and intellectual education continue to nurture the spirits of Randolph County citizens.

John Wesley's Stand, an open-air tabernacle, was built in 1921 by the Rev. J. Frank Burkhead, who began preaching a regular revival service at the old Robbins family cemetery in 1903. During the 1939 summer, 2,900 people attended a service, camping out and listening to the message of several visiting ministers.

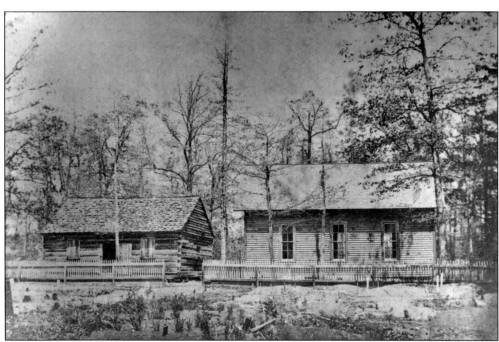

The Abolition Methodists from Indiana established Caraway Wesleyan Church in 1848. Seven Wesleyan churches were founded in North Carolina by these controversial missionaries, who were prosecuted for inciting civil insurrection in Guilford County Superior Court. Four of the churches were in Randolph, including one in Franklinville.

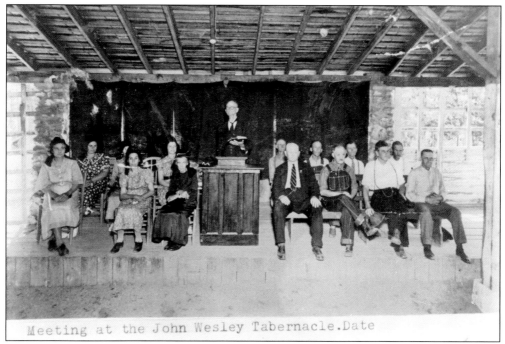

Meeting at the John Wesley Tabernacle.Date

Ministers are seated under the tabernacle at John Wesley's Stand. The Southern tradition of open-air services held in "brush arbors" goes back to Colonial times but has largely died out since the advent of air-conditioning. (Courtesy of Burkhead album.)

The "Bible Rail" or pulpit is pictured at Sandy Creek Baptist Church on November 15, 1953. The last regular service was held in the building in April 1949. Pictured from left to right are elders Walter C. McMillan, L. D. Cashion, and Gurney Nance.

The Holly Spring Friends Meeting was an offshoot of the earlier meeting at Cane Creek, now Alamance County. It became an independent meeting in 1818 and built its second meetinghouse in 1830 with lumber sawn at Jobe Allen's sawmill on Mill Creek. One entrance was for men, the other for women. The building was replaced by another structure in 1889.

This is the interior of the Holly Spring Monthly Meeting of Friends (Conservative), also known as the "Friendsville" Meetinghouse. This was the last Quaker meeting in the county to be built with sliding partitions to divide the building in half. Traditionally this was done to separate the sexes during worship, but at Friendsville the other side was usually used as a school room.

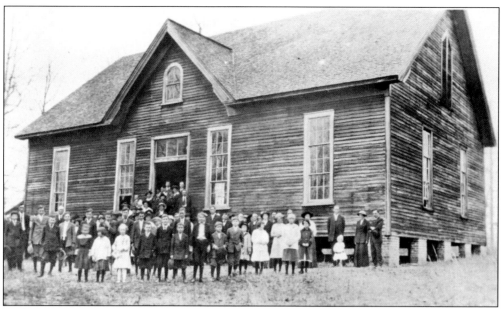

Back Creek Friends Meeting was organized in 1775 and its first meetinghouse built in 1789. The second meetinghouse, shown here, was built in 1901 by Moses Hammond of Archdale at a cost of $500.23. It still stands, after being brick-veneered in 1965. The original image is in the Quaker Historical Collection at Guilford College.

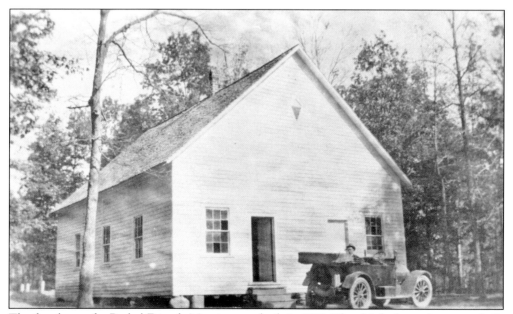

The first house for Bethel Friends Meeting was built in 1821. The third, shown here, was built in 1887 and measured just 26 by 30 feet. It was doubled in size in 1904, and this photograph was taken around 1930. A new brick meetinghouse was built in 1942. The original image is in the Quaker Historical Collection at Guilford College.

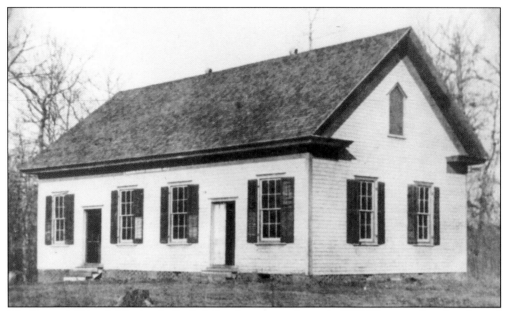

Marlborough Friends Meeting built their first log meetinghouse in 1797. This was their first framed building, constructed around 1875. A chapter of the North Carolina Manumission Society was started at Marlborough in 1825; the last meeting was held here in 1834 after manumission was prohibited by law in 1831 and 1835, and the society could no longer meet openly.

The New Hope Friends Meeting was another conservative meeting built in 1906 near Marlborough. The meeting was laid down in 1960, and the building was subsequently moved to Snow Camp, where it was restored as an exhibit at the *Sword of Peace* outdoor drama.

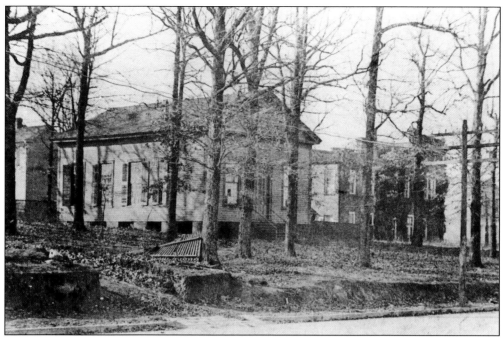

The Asheboro Presbyterian Church was built in 1850 and was the only church of that denomination in the county until 1947.

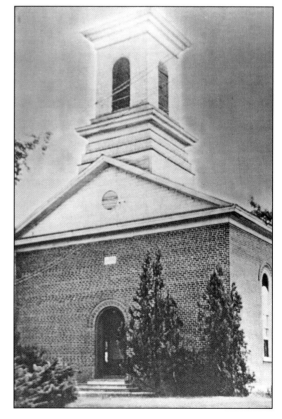

St. Paul's Methodist Episcopal Church was organized in 1855, just seven years after the Union Factory cotton mill was opened. The brick sanctuary was completed in 1880 and was probably the first brick church built in the county. It is presently used as the museum and headquarters of the North Randolph Historical Society.

The Franklinville Methodist cemetery around 1900 shows how differently the deceased were once honored in the landscape. The markers are all scrubbed, not a weed or blade of grass is allowed to grow on the graves, and each one is carefully mounded and marked by a footstone. The entire area is fenced to keep out wandering livestock. Today grass grows everywhere, the mounds have been leveled out, and the footstones have vanished for the convenience of lawn mowers.

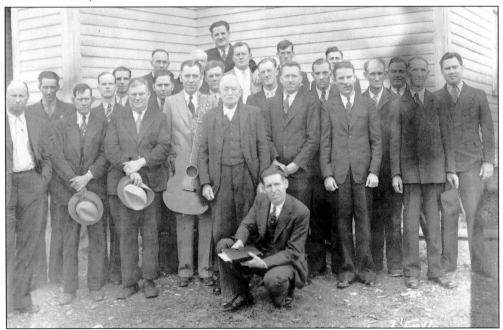

The Oscar Ivey Bible Class of the Central Falls Baptist Church poses with their guitar accompaniment on February 11, 1938. The original union meeting at Central Falls became the Methodist church, but within 10 years, a Baptist congregation had also been organized.

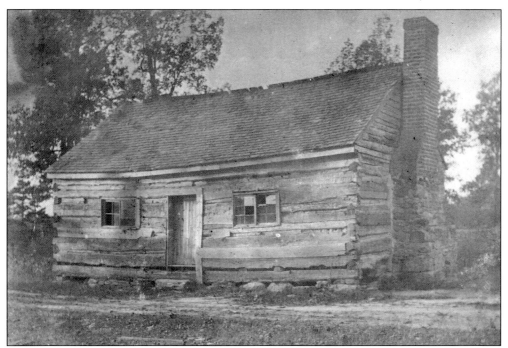

Staley-Payne Schoolhouse in Liberty township was built in 1827, moved to a new location in 1878, and was replaced with a slightly larger structure in 1908. It closed in 1928, and the students were bused to Liberty. The building is illustrative of the earliest schools in the county—one-room log pens with minimal windows and heat. This photograph came from the family of A. H. Henderson and Manie Henderson, two students who attended there.

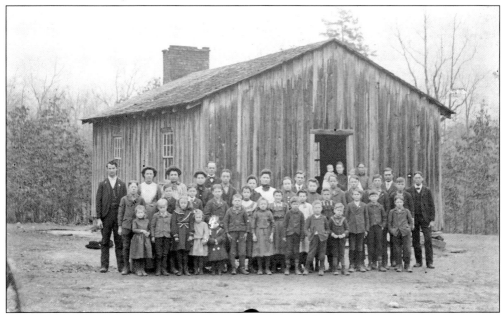

The Antioch School in Brower township had a budget of $120 in 1914. As a one-room school of frame construction, built perhaps in the 1870s, the building was a step up from the early log buildings.

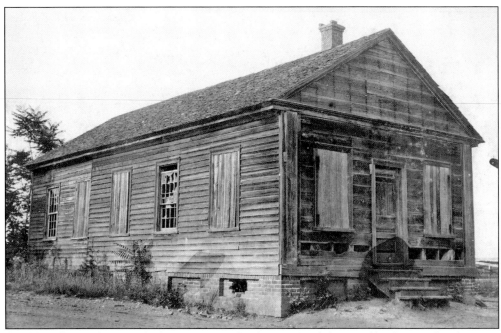

Franklinville Academy was built as a private school in 1845 and chartered by the state legislature in 1851. It was a school meant for college-bound students. This building shows the higher aspirations of its founders, with its Greek Revival details evoking history and higher education.

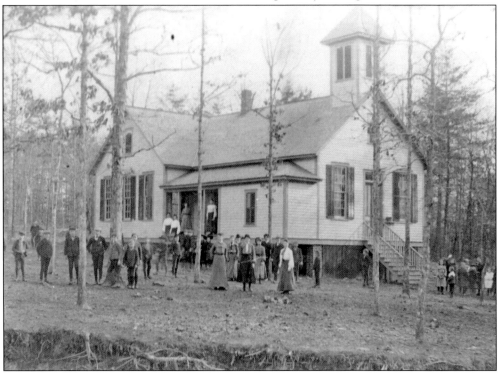

This is the Cedar Falls School around 1880. Probably a three-room school, it was constructed according to state and national standards for education and school buildings.

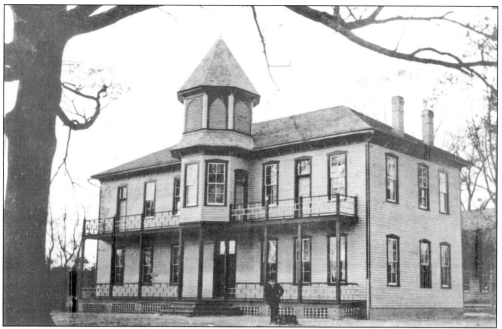

The Belvidere School, built in the 1890s on Sawyersville Road in Back Creek township, had four or more classrooms and represented quite an investment for the local school committee. School design was evolving toward modern ideas of classroom space and instruction.

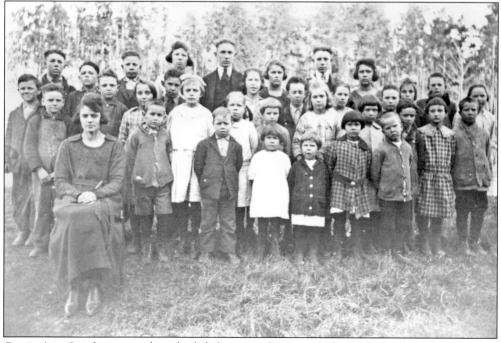

Carrie Ann Lambert, seated in the left foreground, was a teacher at Belvidere School around 1920. It is not clear whether all of the 34 children in the photograph were students—several more may have been teachers, as the only requirement for teaching is that the teacher have passed the grades that were being taught.

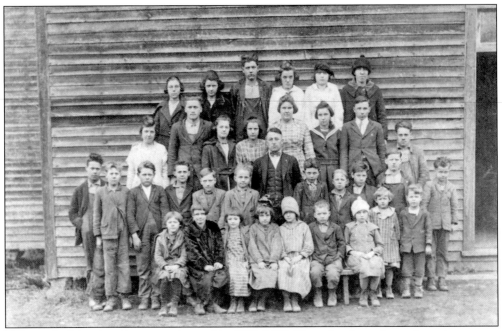

Tabernacle School students are pictured in 1919–1920. The school was located on the present site of the Tabernacle Methodist Church parsonage, several miles from the modern Tabernacle Elementary School. Dewey Loflin is the teacher standing in the middle of the group. There are 34 students with familiar western Randolph family names: Hoover, Younts, Small, Harris, Briles, Gallimore, Varner, Hunt, Kinley, Snider, and Parrish.

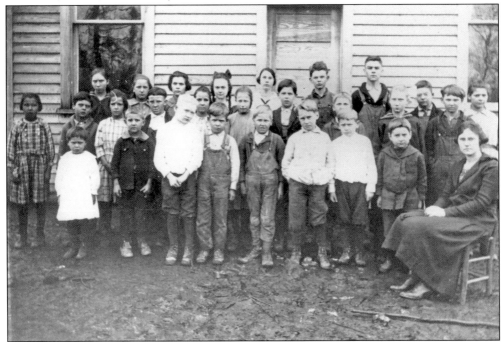

The Locust Grove School, near Parker's Mill, was in Concord township. Edith Spencer, seated to the right, was the teacher here around 1920. She had 27 students in school that day.

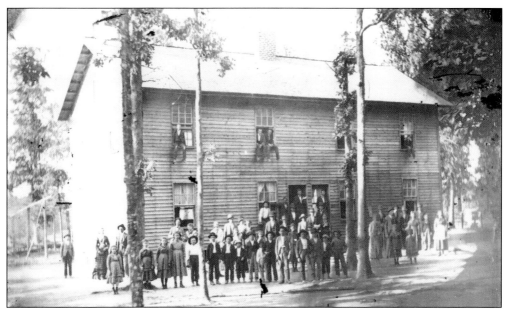

The Pleasant Lodge School, near Liberty, is pictured around 1890. This was probably a four-room school. These 55 well-dressed children and adults may be commemorating a *c.* 1890 graduation ceremony. It is not clear who are the teachers, except that the two men in the doorways are calling attention to themselves by not wearing hats, and one is preoccupied reading a book. (Photograph by J. W. Phillips, photographer of the New Salem area; image printed from a glass-plate negative in the collection of Calvin Hinshaw.)

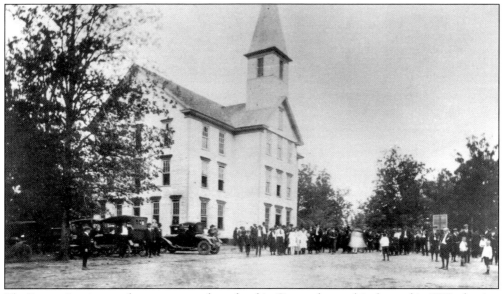

The Farmer Institute, a three-story wooden school in Concord township, burned in 1923, clearing the way for the construction of the old Farmer School building that still stands. The picture must have been taken around 1920, and from the number of people present, it is likely that a commencement ceremony was being held. In the far-right distance, between the crowd and the trees, is an early wooden basketball goal. The Farmer Institute offered classes from grades one through 11—a full public school curriculum.

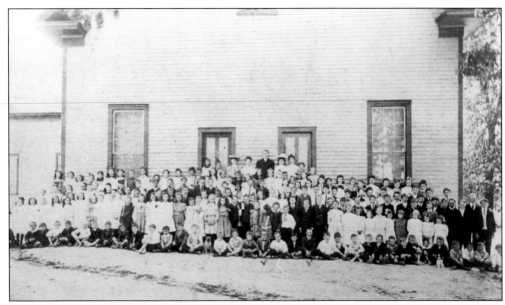

The Asheboro Graded School was one of the larger county schools, and like Farmer, it offered all 11 grades in the one building. Pictured here are the students and teachers in 1903. It was located on the block bounded by Fayetteville, Academy, and Cox Streets, the antebellum site of the Asheboro Male Academy. (MW.)

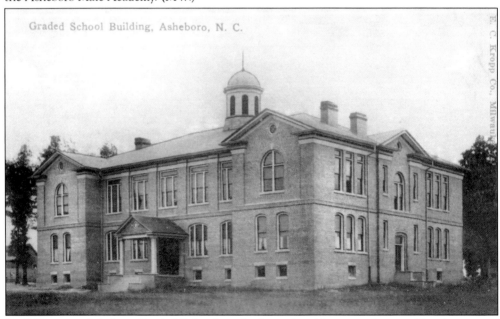

In 1909, a new Asheboro Graded School was built on the old site, a substantial brick structure with 12 classrooms. Asheboro High School was, in 1913, Randolph County's first accredited high school. In the 1930s, the structure was expanded, adding another eights classrooms and an auditorium. The whole Asheboro system expanded by adding new schools, first Balfour Elementary in North Asheboro, then Park Street Elementary (now Loflin). In 1949, a new high school was built, and the old graded school became known as Fayetteville Street School. It was closed in 1968 after the construction of North Asheboro Junior High (now Middle) School.

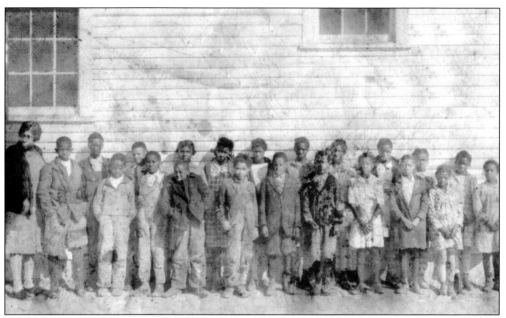

These African American students from the 1920s attended a segregated school in Trinity. While the county school board paid all the bills, they maintained rigidly separate schools for white students and black students. A separate bus fleet was even maintained to serve the black schools. The facilities were not equal in regard to teachers, class size, or buildings until integration occurred in the wake of the 1964 Civil Rights Act. (Trinity Historical Society.)

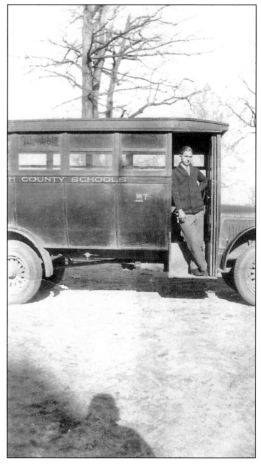

John Charles Redding drove Randolph County School Bus No. 7 to Trinity High School for the 1927 school year. In the 1920–1921 school year, the combined urban and rural schools of Randolph County served 8,490 black and white students in 127 schools. Two "autotrucks" were purchased that same year to transport 52 white pupils from rural one-room schools to the larger graded schools of Liberty and Trinity—the beginning of a trend toward school consolidation that would eliminate more than 100 small schools within the next 20 years.

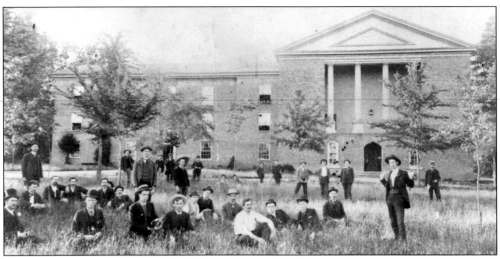

The only institution of higher education in the county was Trinity College, which began in 1837 as a one-room school with students taught by Brantley York. He hired Braxton Craven, a native of southeastern Randolph, to teach, and in 1841 Craven became school headmaster. Craven lobbied for years to gain the sponsorship of the state's Methodists, and when this occurred in 1859, the school became Trinity College. In 1890, Washington Duke, tobacco millionaire and Methodist philanthropist, offered the school $85,000 and 60 acres of land if the institution moved to Durham. In 1892, that new campus opened, and the old Trinity College building became Trinity Graded School. Trinity College in Durham became Duke University in 1924.

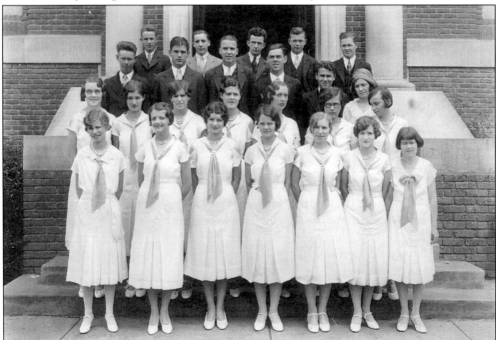

This is the 1931 graduating class of Ramseur High School. The county's rural high schools graduated their own classes until the system was consolidated in the wake of desegregation in the late 1960s. Once Eastern Randolph High School opened in 1969, Ramseur, Franklinville, Grays Chapel, and Liberty became primary schools.

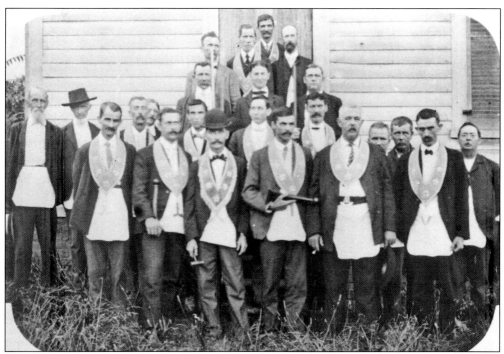

These are members of Hanks Lodge No. 128, the Ancient, Free, and Accepted Order of Masons, around 1890. The lodge was in operation in Franklinville before April 1850 and was granted a charter December 6, 1850, the first in the county. Hugh Parks, owner of the mills, is second from the right in the first row. The lodge building was constructed in 1850 and is still standing. (MW.)

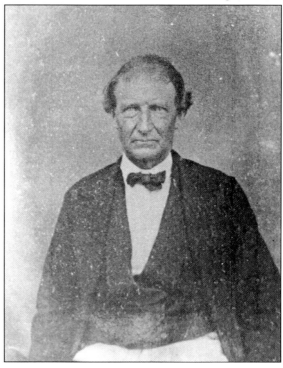

This is George Makepeace (1799–1872) around 1855. Makepeace appears here to be wearing his Masonic apron and was a member of Hanks Lodge and Blackmer Lodge in Montgomery County. Elisha Coffin, on a trip to purchase machinery for the new factory in 1838, hired Makepeace to come to Franklinville and superintend the operation of the factory. Makepeace, experienced in running factories in Massachusetts and Rhode Island, taught many of the postwar generation of industrialists how to be successful textile entrepreneurs. (MW.)

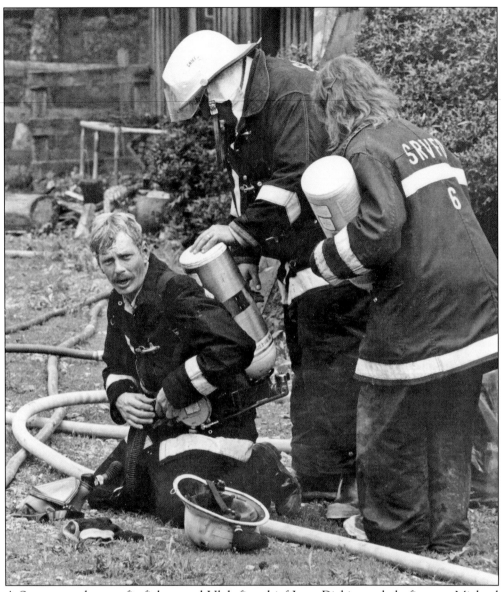

A Seagrove volunteer firefighter and Ulah fire chief Jerry Dickinson help fireman Michael Dickinson change his air tank as Holly Hill Candle Shop on Yow Road in Seagrove burns on April 24, 1987. Nonprofit volunteer fire departments were founded in the 1960s to provide protection and extend insurance coverage for the rural areas of the county. (Courtesy RCPL *Courier Tribune* collection by Blair Callicutt.)

Six

A Place to Serve

In dedicating the Confederate Monument at the county courthouse in 1911, Chief Justice Walter Clark noted that "from the very beginning of the war to its close, wherever there were hardships to be endured, sufferings to be borne and hard fighting to be done, there the county of Randolph was represented, and represented with honor." Service to the community, with honor and, if necessary, with sacrifice, is what protects what is inherited from the past and ensures progress of what is given to the future. Honoring the service and sacrifice of the individual does not require accepting the philosophy or justification of their actions. Just as the county's nine companies of troops sent into Confederate service are honored, the 2,500 citizens who voted against secession in 1861, opposed the war in the election of 1864, or joined the Heroes of America or "Red String" to hide deserters and prison camp escapees can also be honored. Those who opposed Governor Tryon's government in the Regulation; the Whigs and the Tories who fought each other in Revolutionary guerrilla warfare; and the Quakers, Wesleyans, and conscientious objectors to the institution of slavery who helped smuggle human contraband to Ohio and Indiana should also be honored. The residents give back and build their community, through service in government, politics, law enforcement, public safety, as well as through military service. Any service may entail sacrifice, but all service is a gift to the place where one lives.

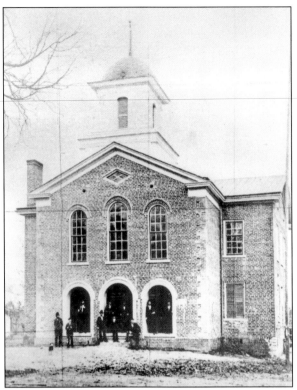

The sixth Randolph County Courthouse stood at the intersection of Salisbury and Main Streets from 1835 to 1909. The public square was located as close to the geographic center of the county as surveyors could determine. The town of Johnstonville in New Market township served as county seat from 1785 until 1792. The first court met at this new site on June 12, 1793, but the city of Asheborough was not chartered by the state until December 25, 1796.

The seventh Randolph County Courthouse was built on the windmill lot, part of Dr. Worth's cow pasture. Seven similar courthouses were designed and built by its Charlotte architects. It was in use until 2003 and was reopened as county offices in 2010. The Confederate monument was added in 1911.

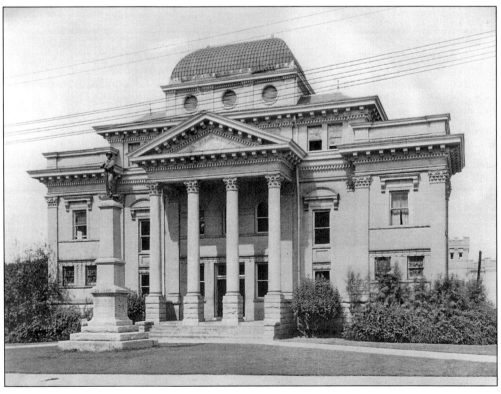

This stand-up desk belonged to the "High Sheriff," who stored tax records and receipts in the pigeonhole compartment locked by three separate keys. It was probably made as part of the furnishings of the 1835 courthouse and was used until 1938. It was photographed on February 5, 1943, and captioned "This rugged age-old Desk . . . should ALWAYS remain in the Randolph County Courthouse and receive care and the respect that is its due in its ripe old age." Its current whereabouts are unknown.

When the 1909 courthouse was built, it was specifically designed to contain fireproof vaults for the storage of county records. This is the interior of the clerk of court's vault in 1940, when county historian Laura Worth used part of the room as an office. Before the invention of file cabinets, loose papers were labeled and tied together and stored in bundles such as these, called "shucks." The red and white woven cord, or tape, used to tie up the shuck is the origin of the bureaucratic term "red tape." Most of these documents are now in the state archives in Raleigh.

The single courtroom of the 1909 courthouse served many functions over 100 years. It was modernized by local architect Hyatt Hammond in 1964 and is currently being remodeled to host public meetings. Here attorney Jon Megerian speaks to a capacity crowd assembled on February 21, 1985, to protest the county tax department's revaluation process. (Courtesy RCPL *Courier Tribune* collection by Blair Callicutt.)

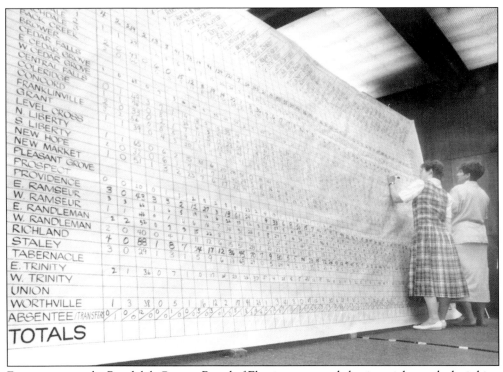

For many years, the Randolph County Board of Elections reported election night results by inking the final vote tallies into the appropriate box on these huge paper sheets hung up in Courtroom A. It took a long time to count the paper ballots and a while longer to get the totals written up.

The Randolph County Democratic Women host a political gathering in Courtroom A, in either 1952 or 1956. From left to right are Kate Hammer, the first woman to register to vote in the county after ratification of the 19th amendment; Maxine Burrows; Minnie Hancock Hammer, president of the Democratic Women; and Elizabeth "Buffie" Ives (1897–1994), the speaker. Ives was the sister of presidential candidate Adlai Stevenson. She lived near Southern Pines with her husband, a retired diplomat.

In 1988, the television news show *60 Minutes* came to profile newly elected Randolph County commissioner Richard Petty, visible at the far left (without his trademark hat and sunglasses). Hidden behind his head was county manager Frank Willis, and then from left to right are commissioner chairman Darrell Frye, county attorney Ed Gavin, and commissioners Floyd Langley and Kenyon Davidson. Standing at the podium behind the boom mike is county planning director Hal Johnson.

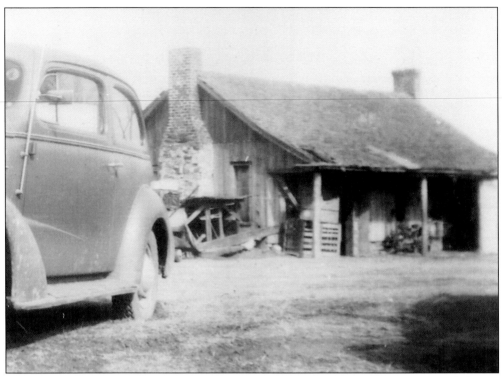

This is the Randolph County Poor House around 1930. The Overseers of the Poor provided room and board for the county's indigent or helpless residents on a site near Caraway Mountain from the 18th century until the 1920s. The County Farm was the first social service work undertaken as a public responsibility. (Courtesy of Juanita Kessler.)

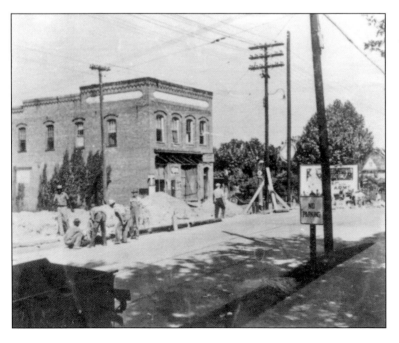

Water and sewer lines are being installed along Salisbury Street in Asheboro around 1915. The Carson Winningham Grocery Store (later the WGWR radio station) at the corner of North Main Street was built in the 1890s to front on the old Public Square. By the 1920s, most cities provided utility services to insure public health.

The county has provided support for public libraries for more than 80 years. During segregation, Asheboro maintained two libraries. The East Side Library was near Central High School, and the white library was in city hall. They merged with the construction of the library on Worth Street in 1964. The Bookmobile program, however, served both black and white communities: here at St. Peter's in Randleman in 1956 and here at the Maple Grove Grocery in Level Cross, 1954.

Pictured at the groundbreaking for a Courthouse Annex in 1950 are, from left to right, S. G. Prevette, county attorney; S. G. Richardson, county chairman; Dr. J. L. Fritz, county commissioner; Charlie Fagg, county commissioner; and B. E. Davis, county commissioner. The jail built in 1912 is in the background; it and the annex were torn down in 1999 to build the 2002 courthouse. The foundation of the 1913 castle-like jail is brick salvaged from the old 1835 courthouse. Prior jails were located at the southeast corner of Salisbury and Cox Streets, inside a palisade fence together with the stocks, pillories, and whipping post.

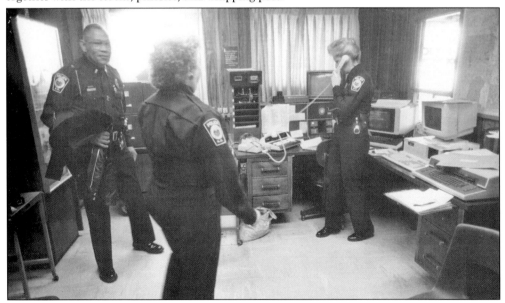

The dispatch and communications office of the Asheboro Police Department is located in the basement of the city hall, as pictured in 1987. From left to right are Lt. Sherrid Austin, Nancy Mason, and Cindy Brinkley. (Courtesy RCPL *Courier Tribune* collection.)

The areas around Grays Chapel, Millboro, and Black Ankle were once well-known haunts of local bootleggers. A bootlegger was originally someone who hid a flask of an alcoholic beverage in his boot, but the term expanded to include those who illegally produced or transported alcohol, or sold it without a license. After the Civil War, government stills were permitted where local farmers could make tax-paid liquor, but a large part of Randolph's underground economy instead depended on the manufacture of moonshine in the wilds of the county. Even the local potters benefited by making jugs for "white lightning." Democrat sheriff Ben Morgan (1946–1950) poses with a confiscated untaxed liquor in 1950. (Courtesy Ben Morgan.)

Starting in the 1970s, marijuana, cocaine, and fraudulently obtained prescription drugs far overshadowed the old traditional vices of bootlegging and gambling. Here Randolph County Sheriff's Department officers inventory the contents of the illegal gambling operation belonging to Dolan Fields in Trinity, where a woman was murdered. Behind the counter are deputies Tommy Julian and Joe Dean Cox. (Courtesy RCPL *Courier Tribune* collection by Todd Sumlin.)

Attending the Asheboro City Council meeting are, from left to right, city engineer Dumont Bunker (mostly out of frame), Lee Phoenix, Frank Edmondson, city manager Tom McIntosh, Mayor Joe Trogdon, planning director Terry Wildrick, Barbara Hochuli, Fred Kearns, Leo Luther, city clerk Carol Cole, city attorney Charlie Casper, and finance officer David Leonard. (Courtesy RCPL *Courier Tribune* collection.)

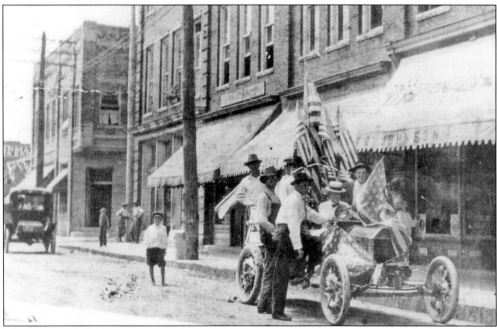

Asheboro's first fire truck leads a parade in 1914; Sulon Stedman is at the wheel. The restored truck still belongs to the City of Asheboro. Clarence Rush joined the city's fire department as a volunteer in 1918, became its chief and first full-time employee in 1939, and retired in 1961. (Courtesy of Burkhead album.)

State troopers Joey Robertson, Rex Carter, and an unidentified person are investigating a murder at the intersection of Gold Hill and Old Cedar Falls Roads outside the Asheboro city limits on October 22, 1988. (Courtesy RCPL *Courier Tribune* collection by Jon C. Lakey.)

Pap's Package Store in Randleman is on fire, as a tanker truck at left explodes on November 9, 1988. Package stores were retail businesses that sold beer for off-premise consumption. Randleman at one time generated substantial sales tax revenue from alcohol sales to citizens of Asheboro, for more than 50 years a "dry" community. (Courtesy RCPL *Courier Tribune* collection by Blair Callicutt.)

The Trinity Guards are gathered in front of the old main building of Trinity College in 1861. When war was declared, approximately half the student body volunteered to fight for the Confederacy, so Braxton Craven formed the Trinity Guard to allow them to contribute to the war effort. For a few weeks during 1861, Trinity students served as guards at the Salisbury Prison. As an element of the Home Guard, the Trinity students spent most of their time keeping order at home, where residents were bitterly divided between secessionists and unionists. (Courtesy of Duke University Archives.)

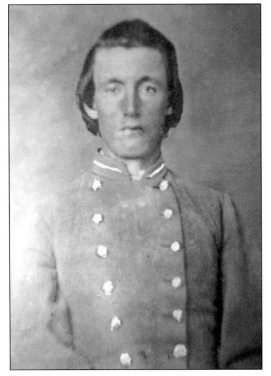

Isaiah Spurgeon Robins (1837–1863) was one of four sons and four daughters of John and Margaret Robins of Cedar Falls, where their four daughters worked in the cotton mill. Isaiah Robins mustered into the Davis Guards, Company I of the 22nd North Carolina Regiment. He was wounded at Chancellorsville in May and died July 1, 1863, when shot through the heart at Gettysburg. His brother William Thomas Robins (1842–1863), a member of Company M, survived Isaiah by three weeks, dying July 23 after an unsuccessful leg amputation. The fourth brother, Madison, was severely wounded but survived the war. Oldest son Marmaduke Swaim Robins (1827–1905), a lawyer, was elected to the state House of Commons in 1862; for a time he was private secretary to Gov. Zebulon Baird Vance. He was also a captain in the Home Guard, tasked with rounding up local deserters.

This photograph of an Randolph County Confederate (found in a Stout family album of Franklinville) represents all those unidentified boys who served and died on both sides. Randolph was never comfortable with the slave economy of the Old South, and local Quakers and abolitionists worked against the system for generations. In February 1861, county citizens voted against leaving the Union by a margin of 50 to one—2,466 against, 45 in favor. Nevertheless, the county sent six full companies of volunteers (more than 700 men) into Confederate service. Many who were drafted soon deserted and returned home, hiding in the woods or hills. The county's reputation attracted escapees from Confederate prisons, where Quakers and "Red String" Unionists would guide them North. For most of 1864 and 1865, the county was under martial law. (MW.)

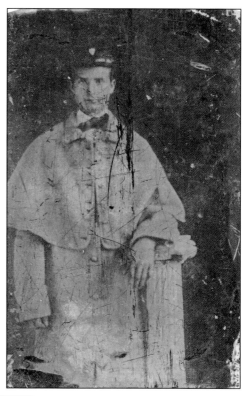

Howell Gilliam Trogdon (1841–1910) and his daughters Isabella and Jane are pictured in 1906. Born on the family farm between Cedar Falls and Franklinville, Howell's family moved to Arkansas in the 1850s. Trogdon enlisted in the 8th Missouri "American Zouaves" and was awarded the Congressional Medal of Honor for his part in Grant's assault on Vicksburg, Mississippi, on May 22, 1863. He is the only Randolph County native to be awarded the nation's highest military honor. (MW.)

Surviving Randolph County veterans meet in Ramseur in 1915. From left to right are Capt. Y. M. C. Johnson, John Tyler Turner, Daniel Burgess, Aubrey Covington, Robert Tate McIntyre, and Murphy Burris. Burris was the miller at Franklinville, and Turner was the author of the only service record for any Randolph company—Company M of the 22nd North Carolina Regiment, the Randolph Hornets.

When the war ended in April 1865, northern Randolph County was shaping up to be the final battlefield. Confederate troops retreating before the Union advance forces were camped from Liberty to Archdale, preparing for the invasion, when word came on April 26, 1865, that General Johnston had surrendered. The Southern troops were mustered out of the army in Archdale on May 1 and 2, 1865. Some element of the artillery was camped near Bethel Methodist Church when the end came; after the war, local residents hauled cannonballs, grapeshot, and small arms ammunition to the iron works in Franklinville to sell as scrap. Relic hunters were still finding examples such as this at Red Cross 100 years later.

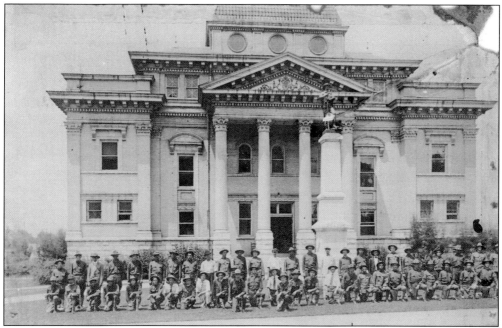

In the early 20th century, Randolph County recruits were mustered into Company K, what would now be called a National Guard unit. One of the company's first assignments was to the Mexican border, as part of the U.S. hunt for Pancho Villa in 1915. This photograph shows Company K in front of the county courthouse, either returning from Texas in 1916 or getting ready to ship out to join the 30th ("Old Hickory") Division of the U.S. Army in October 1917.

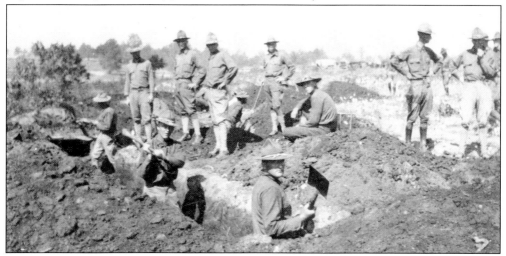

Company K soldiers are digging trenches at Camp Sevier, near Greenville, South Carolina, in late 1917. Supply Sgt. W. C. Craven is sitting on the mound of dirt. Since the 30th Division was made up of National Guard troops from North Carolina, South Carolina, Georgia, and Tennessee, they took the nickname "Old Hickory" Division in honor of Pres. Andrew Jackson, who had a connection to each state. During the Somme offensive in September and October 1918, the division helped break the Hindenburg Line near Bellicourt. Company K was in the thick of that battle and suffered numerous casualties, including its captain, Ben F. Dixon, and Sgt. Thomas J. McDowell.

All three children of Lottie Julian Husband of Franklinville served in World War II: Charles W. Husband, Patsy K. Husband, and Donald E. Husband. Of the hundreds of county residents who served, at least 51 died in the war. Mildred Colleen Presnell was the only known service woman casualty. (MW.)

Technical staff sergeant John A. McGlohon of Asheboro poses in 1942 at Recifie, Brazil, with a camera he is trained to use to take high definition photographs of Army Air Corps bombing runs. When the Enola Gay dropped the first atomic bomb on Hiroshima, Japan, on August 6, 1945, McGlohon was part of a crew returning from another mission; they witnessed the bomb strike and took photographs of the unusual explosion, only later discovering what had taken place. McGlohon's brother Robert, a B-17 bombardier, was killed in action in 1943.

A recruiting poster for the U.S. Marine Corps features Maj. James Henry Crutchfield of Asheboro. Crutchfield, a member of the Davidson College class of 1939, served as a U.S. Marine Corps pilot in World War II and Korea. Flying out of Kangnung, Korea, in November 1951 as member of Marine Fighter Attack Squadron 312 (the "Checkerboard" Squadron), Crutchfield's Corsair was hit by enemy fire while attacking a bridge. He was killed while trying to land in a streambed.

The Asheboro High School Homecoming Parade in 1966 provides a glimpse of the American Legion War Memorial Clock on the southwest corner of Sunset Avenue and Fayetteville Street. It was Randolph County's only public memorial to those who gave their lives in World War I. The funds for the clock were raised primarily by the members of the "Forty and Eight," a special unit of Legionnaire vets named after the capacity painted on French railroad boxcars, which could carry 40 men or 8 mules. The clock was taken down and damaged too badly to restore in 1967, when First National Bank rebuilt its headquarters. "It is later than you think" was the sober message on one face; the other simply said "Honoring All Who Served."

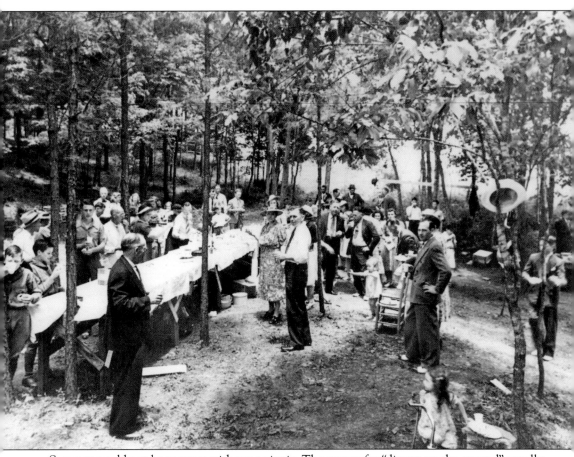

Summer would not be summer without a picnic. The season for "dinner on the ground" usually started in mid-May with Memorial Day homecoming services at rural churches. Originally called "Decoration Day," families would meet at the graveyard on Saturday to hoe away grass and weeds; then the whole church would gather the next afternoon for a picnic and outdoor service where the living honored the dead. This spread of tables was built in the woods adjoining Concord Methodist Church in Coleridge about 1940. (MW.)

Seven

A Place that Makes Living Worthwhile

Human beings perform best when they can manage the daily stress of living and earning. To not merely survive, but to thrive, we need to play. The ways we find to entertain ourselves are as varied as human nature. Some have not changed in millennia, and new ones develop overnight. Some can be enjoyed by hermits, and others require a team, or a crowd, or a whole town. The common denominator is that they allow people to forget problems, to live in the present moment, and to connect to life outside their own. The following scenes are a virtual catalog of how Randolph County residents and human beings everywhere experience the joy and pleasure of what life has to offer.

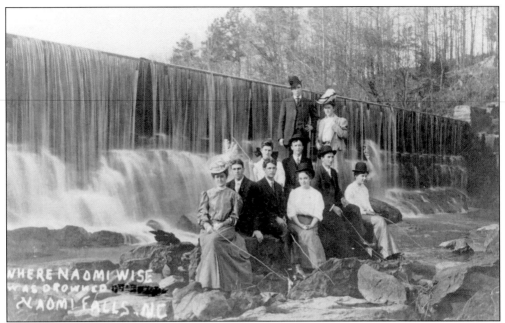

This Picnic party at Naomi Falls Dam is at the site of the drowning of Naomi Wise in 1808. Naomi Wise, an unmarried Randolph County girl, was allegedly drowned at this site by her lover, Jonathan Lewis, in a lover's quarrel in April 1807. Over the years, the story was set to song and is now considered the oldest American murder ballad. Lewis was tried and acquitted for the murder of Naomi Wise in 1811, but he has ever since been found guilty by the song. The music, a living landmark of the event, has been recorded by artists from Doc Watson to Bob Dylan to Elvis Costello.

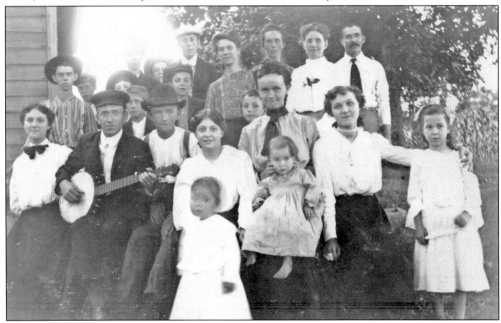

What is going on here? A dance? Wedding? Birthday party? Hugh Parks captured these 22 people on film about 1900 around Cedar Falls or Franklinville. It is not clear what they were doing, but they were poised to have some fun. The two babies, then as now, will not sit still for the camera.

Born in northeastern Randolph County, Adam Manly Reece (1830–1864) was one of the pioneers of the Southern banjo. Reece built the instrument he is holding and became a proficient banjo player before his 18th birthday. How he learned to play the banjo is unknown; before 1860, it was seldom a white man's instrument. Developed by slaves from their native African gourd "kora," the rhythms and syncopations of banjo-style music was foreign to the solo fiddle traditions of the European South. After 1848, Reece transformed the musical heritage of his new home in the Galax, Virgina, area by introducing it to the banjo-based musical tradition he brought from Randolph County. Manly Reece died in a railroad accident near Petersburg while in Confederate service. (MW.)

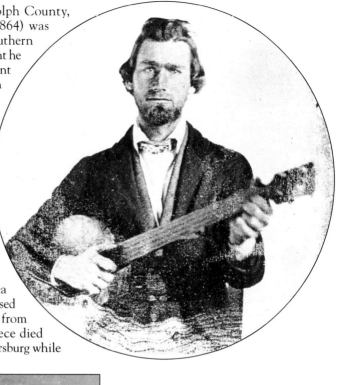

Ellen Bulla is playing the guitar, thought to be a suitable instrument for young women in the 19th century. From left to right are Ellen Bulla, Nannie Bulla, and Della Moss Frazier.

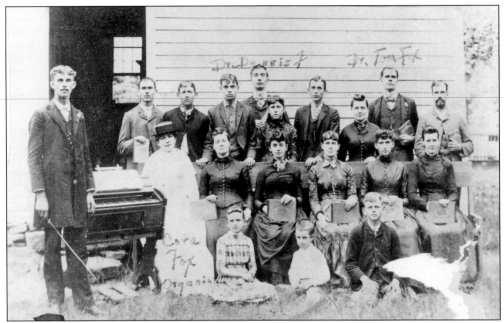

Around 1890, during singing school at Melanchthon Lutheran Church, 17 choir members are proudly displaying their "shape-note" hymnbooks. Dr. Dennis Fox, Dr. Tom Fox, and Cora Fox, the organist, are identified.

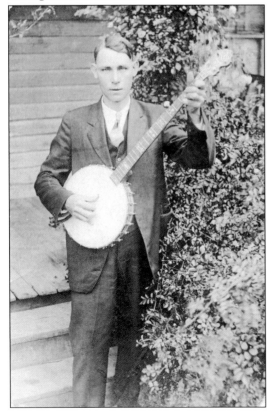

Charlie Poole was born March 22, 1892, in a tiny house still standing in Millboro, Franklinville township. After Poole and his band, the North Carolina Ramblers, went to New York in 1925 and recorded "Don't Let Your Deal Go Down Blues" for Columbia Records, American popular music was never the same. Their recording sold five times more than any other record that year. Poole's success led the music industry to seek out new performers such as Jimmie Rogers and the Carter Family. Poole and his band are members of the Country Music Hall of Fame. (Courtesy of Kinney Rorrer.)

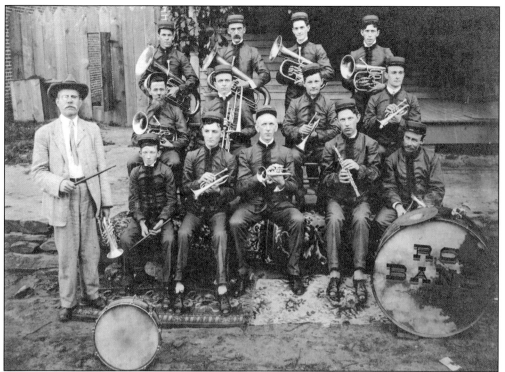

Before World War I, each village along Deep River supported either a brass or string band. Professor Warburton directed the Ramseur Concert Band from 1890 to 1917. The photograph was taken about 1915.

By the mid-20th century, every high school had a brass band class, but the woolen uniforms were primarily to march in parades and football halftime shows. This is the Central High School band in East Asheboro around 1960. (Courtesy of RCPL Ralph Bulla Collection.)

This String Band "jam", around 1965, is at a Randolph country store. The group has plenty of depth: four acoustic guitars, one electric bass, one mandolin, a fiddle, and a banjo. If the music does not keep them warm, the potbellied stove will. (Courtesy of RCPL Ralph Bulla Collection.)

An unidentified group is gospel singing at WGWR studio around 1968. WGWR was the county's first radio station, going on the air in 1948. (Courtesy of Ralph Bulla.)

The sweltering Southern summer dictated a slower pace to life before air-conditioning. Sitting on the porch of a country store, talking and smoking, was a cherished way of passing the time. The identity of the store is unknown but was somewhere in southern Randolph. (MW.)

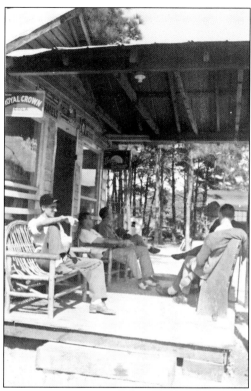

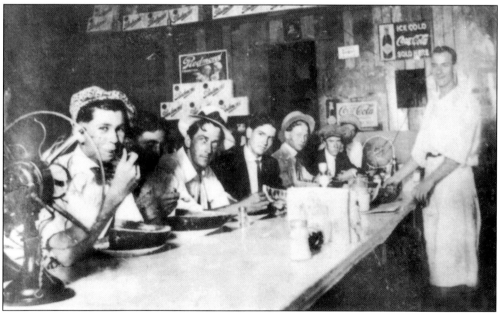

A group of young men are celebrating with a watermelon feast at Hasty's Café in Asheboro in 1916. From left to right are Archie Burkhead, Clifford Morris, Tom McDowell, June Frazier, Ransom Wiles, Bob Bunch, and Ralph Whatley. The counter man is unidentified. Within a year, most would be serving in the U.S. Army. Sgt. Tom McDowell would not return alive. (Courtesy of Burkhead album.)

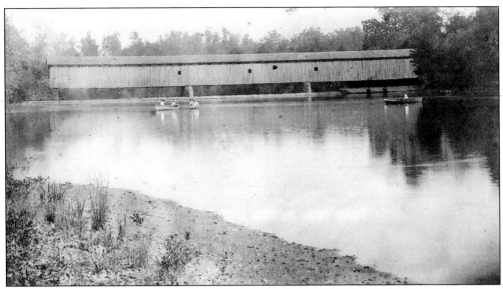

Pictured is pleasure boating on Deep River at Worthville. Another kind of boating used a steam-powered barge to ferry cotton down to the mill at Central Falls and back.

Franklinville boys are swimming in the "whirlpool" in Deep River above the covered bridge. No bathing suits were necessary. Hugh Parks took this photograph around 1910. (MW.)

Camping out, once a necessity, soon became an adventure. This young man is camping along Deep River. (MW.)

As the century advanced, camping was less outside and more comfortable. Here the Reverend J. Frank Burkhead and the Reverend J. W. Holder sit outside a 1920s school bus turned caravan at the annual John Wesley's Stand revival in 1939. (Courtesy of Burkhead album.)

The Boy Scouts of America were founded in 1910 as part of an international movement. Randolph County is in the Uwharrie District of the Old North State Council and supports troops in Asheboro, Seagrove, Ramseur, Liberty, Randleman, Farmer, Franklinville, and Gray's Chapel. The Seagrove School troop is shown here around 1940. Lowell Whatley is second from left in the first row. (MW.)

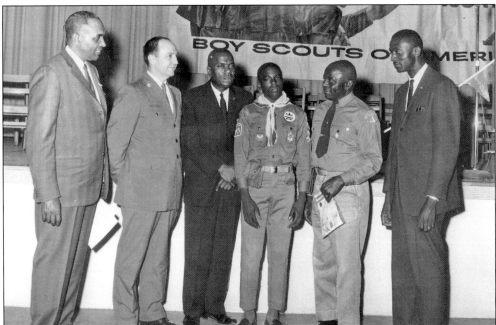

Until 1948, all southern councils of the Boy Scouts of America (BSA) were racially segregated. "Colored Troops," as they were officially known, began to integrate with white local white troops in 1940. The Old Hickory Council in northwestern North Carolina was the last Scout organization in the country to integrate, in 1974. The BSA "Colored Troop," pictured here about 1960, met at Central High School.

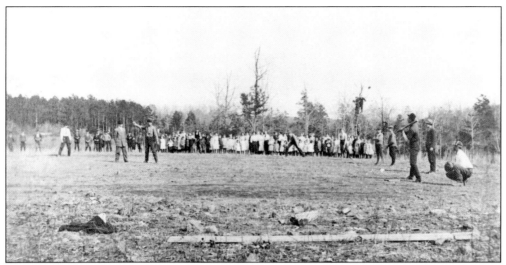

A sandlot baseball game is being played at Coleridge around 1910. Baseball has been popular in the South at least since teams of prisoners began to play at the Salisbury prison camp during the Civil War. Trinity College began playing the University of North Carolina, Chapel Hill and North Carolina State University in the 1880s.

Pictured is the Ramseur baseball team around 1920. The local mill villages joined in the "Deep River League" before 1903, and the games between those communities were cutthroat contests for community pride and pecking order. Hundreds of fans packed the local ballparks on hot summer evenings, and rivalries between neighboring communities became intense.

This is Asheboro's semiprofessional baseball team around 1908. Hal M. Worth, second row, far left, was the manager. The players were, from left to right, (first row) Idyl Ferree, William Armstrong, Charles M. Fox, ? Presnell, and Clarence Rush; (second row) ? Winslow, Sulon Stedman, Colin G. Spencer, and two unidentified. (Courtesy of Burkhead album.)

Walter W. Lindley donated the entrance to Lindley Field to the citizens of Asheboro around 1930. For many years the site of Asheboro High School's baseball and football games, the field was converted to the site for the new Lindley Park Elementary School in 1958.

The Seagrove High School baseball team is pictured around 1948. From left to right are (first row) Lowell Whatley, Kelly Bennett, Ralph Sink, Breck Richardson, and Waymon Strider; (second row) Keith Richardson, Lacy Scott, Wayne Hammonds, Charlie Ray Joyce, and unidentified. (MW.)

The McCrary Eagles, representing Asheboro's Acme-McCrary Hosiery Mills, won the 1937 North Carolina semipro state title and competed in the national championships in Wichita, Kansas. This unidentified player wears an Eagles uniform from the late 1930s. (MW.)

World War II may have ended semiprofessional baseball, but the 1950s saw the beginnings of business support for teenage baseball, like this Klopman little league team.

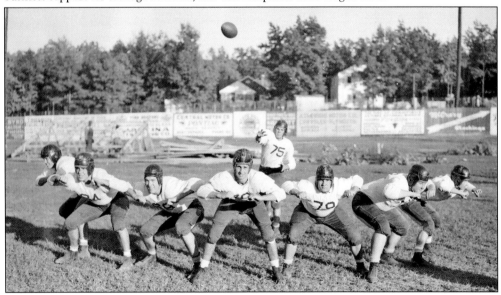

The Asheboro High School football team in fall 1946 is at Lindley Field. The line is, from left to right, Boo McRae, Bill Lloyd, Johnny Ingram, Bill Underwood, Pete Hogan, Donald Dobbins, and Hal Pulliam. C. A. Frye just threw the pass from the backfield.

Schools began to provide physical education before 1915. Here at Franklinville School, the students are taught to exercise with Indian clubs. The practice of swinging wooden clubs to develop fitness was first introduced by British soldiers who discovered the exercise while stationed in India. Groups were led in choreographed routines by an instructor and functioned like a modern aerobics classes. (MW.)

Basketball, originally played outdoors, joined baseball on the list of school sports at the turn of the 1900s. Here is the 1930–1931 Farmer High School basketball team.

The horse show is at the Randolph County Fairgrounds around 1950. Lee J. Stone presents a ribbon to a winning horse and rider in the ring in front of the grandstand. The county fairgrounds, including a racetrack, grandstand, and show barns, were located behind Lucas Industries (later G. E. and Black and Decker) in Asheboro.

Lee Petty (1914–2000), shown here flanked by his sons Maurice and Richard, was one of the first superstars of NASCAR racing. His first race was in 1949 at the Charlotte speedway, and he finished in the top five drivers (ranked by points) for NASCAR's first 11 seasons. He was the Grand National Champion three times and won the inaugural Daytona 500 in 1959. Richard went on to have a pretty good career in racing, and Maurice was the mechanical whiz who built high performance engines for the family business, Petty Enterprises. This photograph is from the 1967 Randleman High School yearbook.

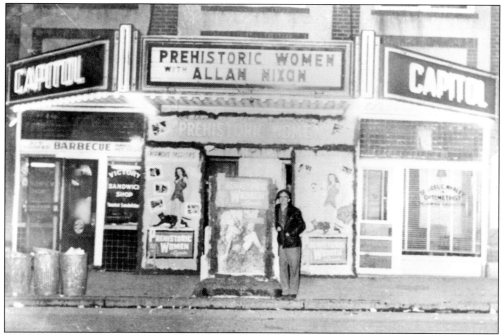

The Capitol Theater was built in the early 1920s on Fayetteville Street in Asheboro to be a full-fledged vaudeville theater. By the 1950s, it had been reduced to showing soft core B-movies like *Prehistoric Women*.

The Sunset Theater in Asheboro, built in 1929, was the first theater built especially for motion pictures, but it has hosted many other events over the years. Here it was the site of the 1946 Bur-Mill employees' family day gathering.

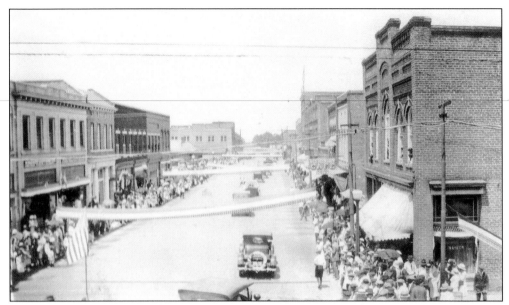

There have been parades as long as there have been people. Crowds gather here at the corner of Fayetteville Street and Sunset Avenue in Asheboro to watch the Fourth of July parade in the 1920s.

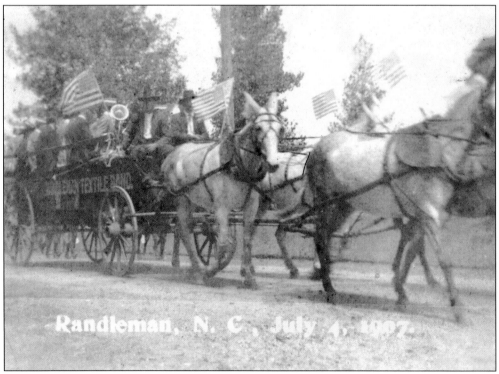

The Randleman Textile Band float parades down Main Street in Randleman on July 4, 1907. Randleman was the first mill community to start a community band—in the 1880s.

The last traditional county fair was held in the early 1960s. To fill the gap, local festivals and events grew up in the 1970s to highlight the heritage and culture of the county. The Fall Festival in Asheboro was among the first and was soon followed by street fairs in Seagrove, Ramseur, Franklinville, Randleman, and Archdale. Attendees here bid at the Seagrove Pottery Festival on November 20, 1988. (Courtesy *Courier Tribune* collection by Jon C. Lakey.)

In the early 1970s, Purgatory Mountain—the old Civil War outlier hideout south of Asheboro—was chosen as the site for the new North Carolina Zoological Park. It opened in 1974 as the nation's first state-supported zoo and remains the nation's largest walk-through natural-habitat zoo. Here one of the first exhibits, the lion habitat, is under construction. All of the rocks were carefully designed to emulate the native Purgatory Mountain stone and built so the concrete structure blends into the naturalistic setting. The result is a place that seems more like central Africa than Randolph County—where the animals are at home, though far from home.

DISCOVER THOUSANDS OF LOCAL HISTORY BOOKS FEATURING MILLIONS OF VINTAGE IMAGES

Arcadia Publishing, the leading local history publisher in the United States, is committed to making history accessible and meaningful through publishing books that celebrate and preserve the heritage of America's people and places.

Find more books like this at
www.arcadiapublishing.com

Search for your hometown history, your old stomping grounds, and even your favorite sports team.

Consistent with our mission to preserve history on a local level, this book was printed in South Carolina on American-made paper and manufactured entirely in the United States. Products carrying the accredited Forest Stewardship Council (FSC) label are printed on 100 percent FSC-certified paper.

MADE IN THE

USA